BASIL & ELISE GOULANDRIS FOUNDATION
Museum of Contemporary Art
Andros
26 June ⁄ 25 September 2005

METAMORPHOSIS
BRITISH ART OF THE SIXTIES

Works from the Collections
of the British Council and the Calouste Gulbenkian Foundation

UMBERTO ALLEMANDI & C.

METAMORPHOSIS
BRITISH ART OF THE SIXTIES

Works from the Collections
of the British Council and the Calouste Gulbenkian Foundation

ANDROS

2005

*The Basil and Elise Goulandris Foundation would like to express their sincere gratitude
to the British Council and the Calouste Gulbenkian Foundation for making this exhibition possible.*

We thank particularly
Emílio Rui Vilar, President of the Board of Trustees of the Calouste Gulbenkian Foundation

We would like to express our wholehearted thanks to
The curators of *Metamorphosis: British Art of the Sixties*, Richard Riley, British Council, London,
and Ana Vasconcelos e Melo, Calouste Gulbenkian Foundation, Lisbon
Jorge Molder, Director of the Modern Art Centre José de Azeredo Perdigão (CAMJAP)
Andrea Rose, Director of Visual Arts, British Council, London
Diana Eccles, Collections Manager, British Council, London
Susan May, Head of Arts Council Collection, Hayward Gallery, London
Jill Constantine, Curator, Arts Council Collection, Hayward Gallery, London
Isadora Papadrakakis, Head Creativity and Society, British Council, Greece

Warm thanks are also extended to
Marcus Alexander, Honor Beddard, Gareth Hughes, Hannah Hunt, Richard Nesham, Teresa Cartaxo,
Paulo Costa, José António Nunes de Oliveira, Carlos Gonçalinho, Mariana Basto, Elizabeth Martins, Isabel Zarazúa,
Cláudia Câmara, João Paulo Dias, Niki Zahioti, Eleana Pathiakaki

We would also like to express our heartfelt thanks to
ERT (Hellenic Broadcasting Corporation)

FOREWORD

T his exhibition, named *Metamorphosis* after an early work by Bridget Riley (1964), which is among the works on display, highlights the substantial transformations which occurred in the arts during the particularly creative period of the 1960s.

During this period of economic prosperity and social euphoria, Britain, and London in particular, played a major role in the formation of contemporary iconography. This influence was cultivated by groups or individuals whose creative and ideological relationships are not always obvious, but whose collective output contributed to the revival of visual language and to the dynamism which came to characterise all creative life in Europe and the United States.

The Basil and Elise Goulandris Foundation has brought together a representative selection of significant works of art by thirty-one internationally renowned figures who have influenced generations of artists.

The exhibition was conceived and is being presented in close collaboration with the British Council in London and was made possible through its generous lending programme. An equally important contribution has come from the Calouste Gulbenkian Foundation in Lisbon, which has acquired an important collection of works from this period, thanks to the vision of its staff and assistance from the British Council.

We offer warm and sincere thanks to both organisations and particularly to the directors and members of the Boards of Trustees of the British Council and the Gulbenkian Foundation. We also thank Richard Riley and Ana Vasconcelos e Melo for curating the exhibition and for their scholarly texts for the accompanying catalogue, and Desmond Lauder, Director of the British Council in Athens.

We also offer our thanks to ERT for their ongoing and valuable promotional sponsorship.

Finally, we offer particular thanks to the resident staff and special collaborators who have worked enthusiastically for the realisation of the exhibition.

FLEURETTE P. KARADONTIS

President of the Basil and Elise Goulandris Foundation

FOREWORD

It could almost be said that this exhibition is a historic reunion: as when members of the same family, estranged by life, sometimes meet again, to rekindle for a few moments the kind of memories that only come up during that kind of reunion (or reunification).

The history of the Calouste Gulbenkian Foundation's British Art Collection is well known, as are the conditions and circumstances of its emergence, the movements and cadences of its growth and even such discrepancies and apparent discontinuities (almost inevitable, as persons and opinions change) as can be found in it. Thus Time marks most of its long-lived children.

Here, relatives born between 1957 and 1971 stand reunited, allowing us to revisit an era and, more than that, an outstanding combination of qualities that always feels like a fresh experience, no matter how often we visit it.

The historic importance of this moment and the birth and growth of the collection have been thoroughly detailed by Ana Vasconcelos e Melo and Richard Riley, rendering any additions more than superfluous.

It is now time to thank the Basil & Elise Goulandris Foundation for hosting this reunion and metamorphosis - indeed, all auspicious meetings bring about enriching changes - in this place where men and gods have so often mingled.

JORGE MOLDER
Director of the Modern Art Centre José de Azeredo Perdigão (CAMJAP), Calouste Gulbenkian Foundation

CONTENTS

TRANSFORMING DAILY LIFE INTO ART
KYRIAKOS KOUTSOMALLIS*

The 1960s (for the purposes of this exhibition, spanning the period 1957-1971) was a splendidly fertile and creative period for the arts in general, but especially for the visual arts. New ideological movements - combined with historical, economic, social, political and cultural changes and rapid scientific and technological evolution - brought about and helped establish new expressive standards and a new iconographic language, the principles of which were at odds even with those of the avant-garde movements of the beginnings of the century. Post-war society, which saw its future being based on the supremacy of materialism and consumer prosperity, needed an art which could serve its values: an art which was liberal and popular, without boundaries and barriers; an art which posed varying challenges; which could be expressive of its era and gain inspiration from the contemporary urban landscape; an art which could interact with the social assumptions of its time, reflect its consumer practices and recreate the social behaviour of contemporary people in the prosperous post-war urban environment. It needed an art which would have a give-and-take relationship with society; which would be influenced by social dynamism and would in turn influence it and help shape it.

Inevitably, these new trends sought inspiration in a number of theories. This frequently led to unstoppable deviations and, in many cases, had fatal consequences for the future of modernism.

The habit of adding the prefix neo- to the names of earlier movements (such as Neo-Dadaism, Neo-Realism and Neo-Expressionism) did not add to a greater understanding of those movements. On the contrary, it was confusing and distorting. Their vagueness and complexity made it even harder to understand the paradoxes of an era which evolved in a totally unplanned and ephemeral manner through groups whose ideological or technical relationships and interactions are not always easy to pinpoint.

Post-war euphoria and optimism, the enthusiasm for anything new and unusual, and the freedom and vitality of the era, all contributed to radical iconographic metamorphoses which broke away from existing rules. The move away from traditional themes changed the very content of the resulting image.

The influx of technology into everyday life and the consumer drive of a prosperous and complacent society were bound to create and promote new creative forces in all aspects of cultural life: the visual arts, industrial design, fashion, literature, cinema, urban planning, photography and, of course, music, the pop version of which brought about new musical stimuli which have inspired all subsequent generations.

Social events such as the relaxing of moral standards, the fight against racial discrimination and social exclusion, feminism's struggle for equality of the sexes and the student protests in France, together with the destabilisation of the environment, stimulated the development of creative forces and became sources of inspiration for new ideological movements, new aesthetic sensibilities and artistic perceptions and the basis of new modes of urban behaviour and methods of communication.

By means of new contrasting viewpoints, the culture of the sixties triggered new ways of thinking and a neo-realist approach to the images of everyday consumerism. Art sprang from life, from its daily routine, was reconciled with it, was structured on and expressed in the

* Kyriakos Koutsomallis is Director of the Museum of Contemporary Art of the Basil and Elise Goulandris Foundation.

materials of its own industrial production. It took its subject matters from its environment and the artist was required to do little more than be inventive and ingenious, which was facilitated by contemporary advertising techniques.

Ideas for subject matter now came from advertisements, illustrated magazines, cartoons, fashion, design, and, of course, television. Art entered a phase of competition with consumerism. A new iconographic perception which was consistent with the spirit of the age emerged from the overwhelming abundance of advertising imagery. This perception sought its morphological, stylistic and material realisation through the means and materials which were being used to construct the modern world and which therefore had the right to exist and participate in artistic creation. One-off happenings, collages, installations and video were nothing more than the natural outcome of technological development.

During this time, art began to explore its era without any concern for durability. It expressed itself through new sensitivities and was defined by new stylistic principles. It became known as Computer Art, Process Art, Performance Art, Kinetic Art, Minimalism, Land or Earth Art and Op Art. It became cerebral and conceptual, aiming at complete dematerialisation thus calling into question and disputing the very meaning of the term art. The 1960s became a period of vanguard developments rivalled only by the artistic vanguard movements of the beginnings of the century.

Pop Art held a dominant position among these new trends. It was a popular, cross-cultural, informal art and culture movement, in which new methods of artistic expression as well as new lifestyles and behaviours flourished. It started in Britain in 1956, with Eduardo Paolozzi and Richard Hamilton, and almost concurrently in America, with Robert Rauschenberg and Jasper Johns. Artists such as Claes Oldenburg, Andy Warhol and James Rosenquist later made it a New York phenomenon.

As early as the mid-1950s, Abstract Expressionism, the dominant art movement in America, began to feel the pressure from movements which emerged straight after the war in rapidly developing countries: Gutai in Japan, Fluxus in Germany, Neo-Realism in France and Pop Art in Britain, most of which had Neo-Dadaist roots.

Although Great Britain had, in the past, been tentative towards the vanguard movements at the beginnings of the century and great figures such as Sickert and Steer had adopted a lukewarm stance towards the proposals of 'dangerous foreigners', it enthusiastically welcomed these post-modern artistic ideas and took the lead in making the 1960s a milestone in the arts.

Since the mid-war period, artists such as Henry Moore, Barbara Hepworth, Ben Nicholson and Paul Nash, had been ahead of their time, seeking a place in the new art ferment and striving to bring art in their own country out of uncertainty, suspicion, irresolution and isolation. Francis Bacon had also made great efforts in the 1940s to bring British art to the fore.

Since then, younger British artists had began focussing their attention on the new art scene in America, which was becoming known through exhibitions of American art at the Tate Gallery. They realised that Willem De Kooning's Abstract Expressionism, Jackson Pollock's Action Painting and Mark Rothko's Minimalism were losing their early influence and that new artistic currents were beginning to emerge both in New York and on the West Coast.

The emergence of the Independent Group from the ranks of the eminent Institute of Contemporary Art (ICA), which had been founded in 1947 to promote all avant-garde movements, was only natural. In keeping with the group's main aims which were expressed in the *This Is Tomorrow* exhibition at the Whitechapel Art Gallery in 1956, artists, writers, designers, critics and architects began defining the new trends and building the principles of this new, informal artistic movement which the critic Lawrence Alloway, during a group meeting in 1954, aptly christened Pop Art. It may be useful at this point to clarify that the Group which first met in 1954 was responsible not only for the formulation of the central ideas of Pop Art but also of other British art movements of the late 1950s and early 1960s. Their common ground was not style or shared visual language and expression but their references to the new standards brought about by mass, urban culture, their sensitivity towards urban sensibilities, institutions and consumerism. Artists created works by borrowing existing motifs which they then re-conceptualised according to the new semiology of contemporary, urban culture.

Although ever since his student years in Edinburgh, Eduardo Paolozzi had been among the first to express a particular interest in popular culture and later played an important role in the establishment of Pop Art, he cannot be considered among its most authentic representatives. Moreover, he considered himself a surrealist rather than a Pop artist.

Richard Hamilton, the creator of the celebrated collage *Just What Is It that Makes Today's Homes so Different, so Appealing?*, was the first artist to sign a work of British Pop Art, a movement which he wanted to be "popular, ephemeral, expendable, low-cost, mass-produced, youthful, funny, sexy, inventive, commercial" ("Letter to Peter and Alison Smithson", 16.1.1967, in Hamilton, *Collected Works: 1953-1982*, p. 28). He is an intellectual, autobiographical artist who embodies his iconographical and social concerns in every composition by transforming idea into action. He works slowly so that the idea can interact with the thoughts behind the composition which is inevitably the result of a complex, intellectual process.

In contrast to Richard Hamilton, his student at the Royal College of Art, Peter Blake, is one of the most important representatives of the British Pop Art movement. Blake works on his own personal, iconography, incorporating popular images which refer nostalgically to the past into his work. He harks back to his childhood and teenage memories through old photographs or fragments of images which he combines with contemporary elements, to create his own bombastic images of the contemporary world.

Richard Smith, also a student of Paolozzi and Hamilton, and a contemporary and fellow student of Peter Blake, follows his own path. He is an easily recognisable, abstract pop painter whose early works (1961-1962), constructed with geometric elements, are on the fringes of abstraction and are inspired by contemporary packaging and advertising.

In 1961, a new generation of Pop Artists emerged. David Hockney, Derek Boshier, Allen Jones, Peter Phillips, Patrick Caulfield and other students at the Royal College of Art, caused a stir when their work was presented at the *Young Contemporaries* exhibition. This was the beginning of the movement's second phase.

Of these artists, Allen Jones and Peter Phillips both express sensuality in their intensely charged, erotic images. Sexual liberation and the relaxation of morals in general were both highly characteristic of the period. Allen Jones' suggestive or allusive female figures which emerge out of an abstract, colouristic lushness, are a comment on the notion of women as objects, one of the most strongly contested issues of the feminist movement.

David Hockney is among the most eminent of his generation. Like Richard Hamilton, he deals with a personal, autobiographical realism, which is inspired by elements such as graffiti and advertising. In familiar, private spaces such as living rooms, bathrooms or swimming pools he sets dream-like, sensual, homosexual subjects that are deeply influenced by Ron B. Kitaj, Francis Bacon and Jean Dubuffet.

Derek Boshier initially adopted a semi-figurative, mannerist approach to Pop iconography with allusions to the human figure and advertising semiotics, but he turned to pure abstraction after 1964.

Antony Donaldson is a figurative Pop painter. His iconographical vocabulary focuses on the female figure and the automobile in a manner which expresses the spirit and optimism of the age.

Patrick Caulfield follows his own, independent, neo-figurative method of expression, by using clear and vibrant colours and avoiding any reference to popular iconography and the traditional subjects of Pop Art.

In contrast to Patrick Caulfield, Joe Tilson, whose work is closely associated with that of the first generation of British Pop artists, expresses a strong interest in popular art. He is inspired by the urban, industrial environment and by advertising. The use of words as independent semiotic symbols or as visually moulded forms is a particular feature of his work.

Gillian Ayres, the only woman who took part in the influential Situationist exhibitions in London at the beginnings of the 1960s, and Bernard Cohen - both strongly influenced by Jackson Pollock - focus their attention on Abstraction. This is also true of Ian Stephenson and Garth Evans. Robyn Denny and Bernard Cohen also created abstract paintings. Within an entirely shapeless space, vertical or horizontal colouristic alternations are used to create a feeling of exhilaration and a peculiar sense of geometric abstraction.

Through her use of visual effects and two-dimensional optical alternations of white and black and shades of grey, Bridget Riley's compositions explore the visual potential of the optical illusion achieved by the use of wavy lines.

Howard Hodgkin, whose work follows a personal, semi-abstract path, is equally important, but his independent itinerary and interests make it difficult to classify him as a member of a specific movement or group.

This exhibition, which focuses on the various movements that defined British art during the 1960s, brings together thirty-one artists and a considerable number of representative works in a variety of media from the rich collections of the British Council in London and the Calouste Gulbenkian Foundation in Lisbon.

This broad and representative selection gives visitors a comprehensive insight into this historic, though idiosyncratic era, which has charmed and inspired generations of artists.

The exhibition also illustrates significant iconographic changes which, though hatched and developed on both sides of the Atlantic, were eventually imposed by British art, in the days of Swinging London. These changes were structured around the cross-cultural movement of Pop Art, the new forms of expression and subject matter which were directly or indirectly influenced by consumerism and the overwhelming, atmospheric realism of urban culture. And they were changes which were built on neo-abstraction, such as those developed by the renowned Situationists and were influenced by American art and especially by Abstract Expressionism.

The exhibition also covers developments in sculpture during the same period. It shows how and with what materials Anthony Caro conceived and formed its principles and how these were later adopted and absorbed by a group which became known as the New Generation Group, following an exhibition of the same title at the Whitechapel Art Gallery in 1965. Artists who took part include Phillip King, Michael Bolus, Garth Evans, Isaac Witkin, David Annesley – who are all represented in the current exhibition.

This exhibition owes much to three good friends who bore a large part of the burden of preparing and curating it: Richard Riley, curator, British Council in London, Ana Vasconcelos e Melo, curator, Calouste Gulbenkian Foundation in Lisbon, and Isadora Papadrakakis, Head Creativity and Society, British Council in Athens. Our warmest thanks are offered to all three for their exemplary cooperation in preparation for the exhibition and their contributions to the accompanying catalogue.

(Translated from Greek)

METAMORPHOSIS: THE CHANGING FACE OF BRITISH ART, 1957-1971

RICHARD RILEY*

"I think that that period, the late fifties and sixties, was a very exciting moment in the development of British art in the twentieth century. There was a high point in the 1930s when things seemed to really be happening in London, and there was a strong international community including people like Gabo, Mondrian, Moholy-Nagy and architects Gropius, Breuer and so on, but that all collapsed with the war and then it took a long time [...] for things to begin happening again. I don't think it was until the mid-fifties that people began to feel optimistic and positive, when you began to see really important creative stirring in art in this country."[1]

This short summary of the state of British art after World War II was made by Alan Bowness when interviewed in 1996. Bowness had been a member of the advisory committee of the British Council's Fine Arts Department in the late 1950s and early 1960s, and advised on the purchase of contemporary British art for the Calouste Gulbenkian Foundation. This exhibition, spanning a period of fourteen years, 1957-1971, celebrates British art of the 1960s through works purchased at the time for both the Gulbenkian Foundation and British Council collections.

The 1960s has of course been much celebrated as a decade of innovation and change in the artistic landscape of Britain. Technical advances and greater opportunity for freedom of movement and expression played a large part in this turn of events, but the seeds of change had been sown during the preceding decade as the country was finally emerging from the period of austerity and insularity which had hung over it since the immediate post-war years. To place all of this in context, it is perhaps worth reflecting on the situation in Britain in the decade leading up to the war.

A pivotal moment in pre-war British art was the formation of Unit One in 1933. This was a group comprising eight painters (including Ben Nicholson and Paul Nash), two sculptors (Henry Moore and Barbara Hepworth), and two architects (Wells Coates and Colin Lucas), which embraced the modernist concerns of Continental Europe. Although short-lived, a number of the artists in Unit One were to achieve international acclaim which helped place British art within the European mainstream, and Coates and Lucas were both notably instrumental in the advancement of modern architecture in Britain. However, as Bowness noted, the onset of war put paid to the London-based international avant-garde as its leading players moved away: Nicholson and Hepworth relocated to Cornwall, and Moore to Hertfordshire.

Britain was inevitably shattered by the war and in its aftermath there followed something of a retreat into isolationism brought about by a sense of national pride which at the same time harboured a suspicion and rejection of what was happening elsewhere. In art there was a return to a more lyrical, native tradition and out of pre-war English Surrealism grew a more acceptable form of home grown modernism in *neo-romanticism* which found its roots in the rediscovery of visionary artists such as William Blake and Samuel Palmer.[2]

It was against this background that the Institute of Contemporary Arts was founded in London in 1947. It grew out of the perceived need for a centre which promoted European modernism in all its forms, which the founding members felt had been neglected by the Tate Gallery and other major institutions. The first ICA exhibition, *Forty Years of Modern Art: 1907-1947. A Selection from British Collections*, was held

* Richard Riley is Exhibition Curator, Visual Arts, British Council, London.

in early 1948. The exhibition was a celebration of the European avant-garde selected from various collections including those of members of the organising committee, which included such significant champions of modernism as art critic and historian Herbert Read (ICA Chairman) and artist Roland Penrose (Vice-Chairman). It included works by Georges Braque, René Magritte, Henri Matisse, Joan Miró and Pablo Picasso, in addition to work by British contemporaries Francis Bacon, Barbara Hepworth, Victor Pasmore, and a pen and ink drawing by the twenty-four-year-old Eduardo Paolozzi.

Born in Leith, Scotland, Paolozzi had arrived in London at the end of the war. Following demobilisation he had first studied at the Ruskin School of Art in Oxford before transferring to the Slade School of Art, London. At the time he felt totally out of step with the teaching at the Slade, of which he later wrote: "[it] was an enlargement of the ethos at the Ruskin, a sanitised and vague notion of the École des Beaux-Arts tradition and an inexplainable disdain for modernism of any kind. To be an enthusiast of Picasso or Max Ernst excited hostility."[3]

With the proceeds of sales from his first solo exhibition at the Mayor Gallery, London, in 1947, Paolozzi left for Paris. He returned to London two years later and, as with other like-minded practitioners, he was drawn to the ICA as the only place where modern art, design, literature and music were being promoted and discussed. It was at the ICA that a loose group of artists, designers, architects and writers, whose interests combined European modernism with mass culture, science and technology, were to form what eventually became known as the Independent Group.[4] In addition to Paolozzi, other early members included artists Richard Hamilton and William Turnbull. Turnbull had been a fellow student and friend of Paolozzi's at the Slade School and he too lived in Paris in the late 1940s: "I had left London for Paris to escape the prevailing post-war neo-romanticism, and soon after my return to London at the end of 1950, it was a great pleasure to find the ICA with its outward looking international attitude".[5] The first 'official' meeting of the group is generally acknowledged as having been in January 1952 and featured the now legendary "Bunk" lecture by Paolozzi. This consisted of a random series of images culled from American glossy magazines and technical manuals which were projected through an epidiascope (an early form of overhead projector). The lecture has subsequently been credited as being the birth of Pop Art, but in essence it was an extension of Paolozzi's interest in Dada and Surrealism and the practice of collage, albeit incorporating imagery from the glamorous colourful world of American consumer society, which must have seemed a far cry from the grey world of London in the early 1950s.

Collage was integral to the working practice of the Independent Group and was a major feature of their collaborative exhibitions. Paolozzi had been experimenting with the technique from as early as 1943, and Hamilton's famous collage, *Just What Is It that Makes Today's Homes so Different, so Appealing?*, was made as an illustration for the catalogue and as a poster design for the exhibition *This Is Tomorrow* held at the Whitechapel Art Gallery, London, in 1956. The exhibition comprised a series of twelve environments, each a collaboration between artists, designers and architects, and featured many of the major figures associated with the Independent Group. As with Paolozzi's "Bunk" lecture, Hamilton's collage has since achieved a kind of mythical status and has been credited as being the origin of the term "Pop Art" - in large part because the word "pop" appears in the collage, though in fact it had already appeared in a speech bubble in a Paolozzi collage as early as 1947.

The blurring of the distinction between the fine and applied arts was part of the anti-elitist ethos of the Independent Group. During the early 1950s several of the group's members were employed as part-time teachers at the Central School of Arts and Crafts, London, where there was an inter-disciplinary approach to teaching. Paolozzi taught in the Textiles Department and Hamilton on the Basic Design Course, whilst Edward Wright ran an experimental typography workshop. Wright designed the exhibition catalogue for *This Is Tomorrow* and, after transferring to the School of Graphic Design at the Royal College of Art, London, in 1955, his influence was felt in the early work of a number of painting students. The cross-over between the fine arts and commercial design was being actively encouraged at the Royal College and a new generation of students, including Peter Blake, Robyn Denny, Richard Smith and Joe Tilson, were moving between departments and using elements of collage and lettering in their paintings.

If Paolozzi and Hamilton are generally regarded as the first generation of British Pop artists, then Blake, Smith and Tilson are included in the second wave - even though Smith and Tilson, along with Denny, were initially regarded as *tachiste*[6] painters. Denny is not usually associated with Pop, but there was a brief period when elements in his work touched upon similar concerns. For example the billboard scale and use of lettering in his *Austin Reed Mural*, commissioned by the tailors and outfitters for their main store in the West End of London in 1959, has something of a Pop sensibility, and its status as an iconic work of the time was later affirmed when the Beatles were photographed in front of it in 1963.

Important exhibitions of contemporary international art were taking place in London throughout the 1950s. In addition to the programme at the ICA, the enlightened young director of the Whitechapel Art Gallery, Bryan Robertson, was organising ground-breaking exhibitions of art from Europe and the United States, and in 1956 the Tate Gallery mounted *Modern Art in the United States*. Including paintings by a group of artists of the New York School, this exhibition has been documented as being a watershed for British artists of the time, though Denny later commented: "You've got to be careful when you're talking about this period. It's always assumed that Abstract Expressionism at the Tate in 1956 changed the world. Well of course we were influenced by that exhibition, but it was an event waiting to happen".[7]

The first British exposure to Abstract Expressionism and French *Art Informel* had in fact been in the exhibition *Opposing Forces* held at the ICA in 1953. The ICA had then followed this with solo shows of *tachiste* painters, Jean Dubuffet (1955), Georges Mathieu (1956), and Wols (1957), while at the same time the Whitechapel staged retrospective exhibitions of the work of Nicolas De Staël (1956) and Jackson Pollock (1958).

Although the world was opening up and foreign travel was becoming more commonplace, only small numbers were to make it across the Atlantic to the United States until the end of the decade. The seemingly sophisticated and advanced consumer society of America was of course visible to all through the cinema, as was the depiction of a rebellious youth culture and teenage angst in films such as *The Blackboard Jungle* and *Rebel Without a Cause*, both of which were released in 1955. The former is now best remembered for introducing the song *Rock Around the Clock* by Bill Haley and the Comets and thereby unleashing the rock 'n' roll craze that swept Britain, while the latter film, starring James Dean as a disillusioned teenager from a small-town, middle-class family, was one of a number of melodramas of the period which captured an underlying malaise and sense of disillusionment with the values of middle America.[8]

The questioning of authority and kicking against the establishment in Britain was manifested in the novels and plays of the so-called "Angry Young Men",[9] closely followed by the related films of British "New Wave" directors.[10] Owing more to European social realism than mainstream Hollywood, these films gave voice to a disenchanted working class fighting against their condition in the industrial heartlands of England. For the most part, the films appealed to an art-house cinema audience and were not overly popular with the working people whose everyday lives and struggles they purported to depict.

The country as a whole was still going through a major period of readjustment. Its position in the world at large was considerably diminished following the war when the division of power on the world stage had left Britain poor cousins to the United States. While the Suez Crisis of late 1956 was to provide a harsh reminder of this state of play, nonetheless the economy was improving, people were beginning to enjoy a better life-style and the new prime minister Harold Macmillan famously declared in a speech made in July 1957: "Let us be frank about it: most of our people have never had it so good".[11] Yet Macmillan was already sixty-three when he assumed power and, like his immediate Conservative Party predecessors, Sir Anthony Eden and Sir Winston Churchill, he represented an old guard of politicians from a background of privilege and the landed gentry, and was regarded as somewhat out of touch with the lives of ordinary people. Seen against the youth and vigour of President John F. Kennedy, Macmillan seemed like a figure from another age, and it was not until Harold Wilson assumed power in the autumn of 1964 that Britain again had a prime minister under the age of fifty.

The new decade of the sixties was to finally usher in a period of creativity and opportunity. London became one of the world's most vibrant and important centres for contemporary art, design, fashion and music. Stimulated by this new-found confidence and sense of optimism,

artists were pushing at the boundaries of accepted practice, and an emerging generation of artists began to take on the scale, vitality and ambition of American art.

The challenge had been laid down in a second survey exhibition of American painting mounted by the Tate Gallery in early 1959. Entitled *New American Painting*, it concentrated on the work of seventeen artists of the New York School. In addition to Willem De Kooning, Philip Guston, Jackson Pollock, Clifford Still and Mark Rothko, all of whom had been represented in the earlier American painting show of 1956, this exhibition introduced the work of Barnett Newman. The exhibition had a considerable impact on British artists, and the sense of intimacy engendered by the monumental scale of paintings which seemed to envelop the viewer, was to provide a driving force and inspiration behind a British exhibition entitled *Situation* which took place in September 1960. Showcasing the work of twenty artists, it was organised by a committee, largely consisting of artists, and was held at the RBA Galleries, London.[12] The artists included William Turnbull (providing a link with the Independent Group) and Richard Smith (providing a cross-over with Pop), as well as Robyn Denny, Bernard Cohen, John Hoyland and John Plumb. In his introduction to the catalogue, writer and critic Roger Coleman outlined the conditions as set by the committee (of which he was a member): "[the works] should be abstract (that is, without explicit reference to events outside the painting - landscape, boats, figures - hence the absence of St Ives painters, for instance), and not less than thirty square feet".[13] Rather than the gestural values associated with Abstract Expressionism, by this time many of the artists showing in *Situation* were engaged with making paintings of a more formal nature. Coleman's introduction drew attention to this: "The canvas is, more often than not, partitioned into a few simple areas, or fields, which are often very close in tone and hue [...] they are usually clearly defined and consistent throughout each painting. The effect of this is to make the paintings cartographically simple but perceptually complex - a kind of stable/unstable surface".[14]

Amongst the paintings referred to in this context were those by Denny, Cohen, Hoyland and Plumb. Denny had completely moved away from his earlier *tachiste* style and was making hard-edged paintings, the defining elements for which were proportion, spatial organisation and their relationship with the spectator. Such concerns had been evident the year before in a collaborative exhibition he and Coleman, with Smith and Ralph Rumney (all Royal College of Art contemporaries), had devised for the ICA. Entitled *Place*, it featured twenty-four large-format abstract canvases which stood directly on the floor in a maze configuration so as to invite the viewer to become a participant in navigating a physical 'colour-field' environment.

One of the artists in *Situation* who was making avowedly gestural paintings was Gillian Ayres. More than accustomed to working on a grand scale, Ayres had, as early as 1957, completed the *Hampstead Mural*, a single work on four panels commissioned for the dining room of the newly renovated South Hampstead School for Girls. This had been a daring and radical commission for the time and Ayres's creation has been described as "one of the great ensemble works of British abstraction, on a scale unprecedented for such painting in this country".[15] For the mural, Ayres worked on the panels flat on the floor, pouring and dripping paint in addition to working with brushes and rags, and the paintings she presented in *Situation* were also on board and executed in a similar vein. Shortly after the exhibition, she began to work on canvas and the brushwork and use of a softer palette were more evident in these new paintings. She was still working on a large scale and often employing a double canvas (as with *Send Off*, 1962, in the current exhibition), and she exhibited one of these paintings in the second *Situation* exhibition, *New London Situation*, held at the New London Gallery in August and September of 1961.

In addition to sixteen of the artists included in the original exhibition, *New London Situation* also featured a free-standing abstract sculpture by Anthony Caro. Made in steel and painted dark brown, *The Horse*, 1961,[16] was one of Caro's new 'break-through' sculptures made after his first visit to the United States in late 1959. Until then Caro had been working in a figurative tradition, but following his return to London he changed his materials from bronze to steel and began making abstract sculptures which were independent of base or pedestal so that they inhabited their own space. It was a radical break with all he had done before and his achievement was to rid sculpture, as the painters were also doing, of any association with objects and images from the outside world, in particular the figure.

The first substantial showing of Caro's steel sculpture was at the Whitechapel Art Gallery in 1963, and Bryan Robertson later wrote of the "*absolute raw shock*" of the sculpture when first seen by the public.[17] Caro was at the forefront of a revolution in British sculpture and was the inspirational teacher for a group of younger artists studying at St Martin's School of Art, London, in the late 1950s and 1960s, including Phillip King, David Annesley, Michael Bolus, Tim Scott, William Tucker and Isaac Witkin. Using a diverse range of new materials such as fibreglass, plastic and aluminium, the younger artists created their own sculptural language and their work was first showcased in a group exhibition at the Whitechapel, *The New Generation: 1965*.[18] In the catalogue introduction, much of the sculpture was referred to as having an "other-worldliness"[19] due to the impression of weightlessness, but this description would seem particularly apt for the flowing, organic forms in the sculpture of King and Witkin which were like nothing seen before.

During this same period another group of artists, mostly graduating from the Royal College of Art, came to the attention of a broader public in 1961 when paintings by Derek Boshier, Patrick Caulfield, Antony Donaldson, David Hockney, Allen Jones, R. B. Kitaj and Peter Phillips, were included in the *Young Contemporaries* exhibition at the RBA Galleries in February of that year. An annual exhibition organised to promote student painting, sculpture and graphic art selected from open submission, the *Young Contemporaries* was then in its twelfth year. Phillips, Jones and Boshier were all on the student executive committee, and Lawrence Alloway, the ICA Programme Director, who had been closely associated with both the Independent Group and *Situation*, was on the selection committee. In his short introduction for the catalogue, Alloway wrote: "A group seen here for the first time, is of artists (mainly at the Royal College) who connect their art with the city. They do so, not by painting factory chimneys or queues, but by using typical products and objects, including the techniques of graffiti and imagery of mass communication".[20]

The reference to graffiti certainly applied to Hockney who was using words in his paintings of this time; lines from poetry and newspaper articles as well as graffiti. Hockney later spoke of the importance of the *Young Contemporaries* and the position of the young emerging artists: "For a student, the exhibition was a big event. It was probably the first time that there'd been a student movement in painting that was uninfluenced by older artists in this country [...] the previous generation of students, the abstract expressionists, in a sense had been influenced by older artists who had seen American painting. But this generation was not".[21]

This is the point at which British Pop made a real impact. It was seen as young, avant-garde, accessible and entertaining. It was also newsworthy and a number of artists were to quickly gain an unprecedented celebrity status. *The Sunday Times* newspaper launched its first colour supplement in February 1962 with an article on Peter Blake entitled "Pioneer of Pop". That same month Hockney was profiled in *Queen* magazine, and in March, the BBC screened *Pop Goes the Easel*, a documentary film directed by Ken Russell which featured Blake, Boshier, Phillips and Pauline Boty.[22]

New commercial galleries were setting up in London in the early 1960s which were run by dealers of the same generation as the artists who were quick to recognise and support the beginnings of a boom period in British art. It was not surprising therefore that a number of the selected artists had already had solo exhibitions before their inclusion in the first of the *New Generation* exhibitions which opened at the Whitechapel Art Gallery in March 1964. Focussing on the work of twelve painters, *The New Generation: 1964* has since been accorded considerable importance because it showcased numerous artists who then established significant careers, including Boshier, Caulfield, Donaldson, Hockney, Jones and Phillips, all associated with Pop, and Hoyland, Paul Huxley and Bridget Riley working in an abstract tradition.[23]

This mixed grouping is noteworthy given that the prevailing assumption is that there was a distinct division between abstract and Pop tendencies, when in reality the situation was never so cut and dried. There was, as always, dialogue between artists and close friendships formed which transcended the superficiality of style. It is interesting now looking at installation photographs of the *New Generation* exhibition to see the fluid abstract paintings of Huxley hung in close proximity to the painterly figuration of Allen Jones. Some years later, when John Hoyland was invited to select the *Hayward Annual* exhibition of 1980,[24] in a show which was unashamedly abstract and in the

main showcasing large-scale painting, he included a domestic-sized still life painting by Patrick Caulfield. In his introduction, Hoyland spoke of his selection as being on the grounds that all the artists "work within established conventions of the modern tradition [...]. The boring abstract-versus-figurative argument does not concern me here".[25]

Although relatively short lived, British Pop has had a lasting legacy and still permeates the art of today. The term, however, has tended to be used as a convenient way of grouping artists of a time but it is one which has also proved to be continually misleading. Forty years on and it is still used to describe the work of artists who were never strictly concerned with popular culture. Two distinctive cases in point are David Hockney and Patrick Caulfield. Although Hockney had made a student painting in 1961 in the shape of a packet of tea,[26] and Caulfield's simplified style had similarities with the techniques employed by commercial artists, both were more interested in exploring existing styles in art. Hockney from Egyptian to Cubist, and Caulfield, taking inspiration from such modern European masters as Gris, Léger and Matisse, was making work which was "emblematic and decorative, yet still using traditional and familiar imagery".[27]

Another artist of the same generation who has avoided such categorisation throughout his long career is Howard Hodgkin. Perhaps because it has been impossible to do so, he does not easily fit into any obvious grouping. His paintings fall somewhere between representation and abstraction, with subjects based on specific experiences, fleeting moments in time and people he has known. Frequently working on paintings over long periods, throughout the sixties he made a number of portraits of artist friends and their partners, including *Mr and Mrs Patrick Caulfield*, 1967-1970, in the current exhibition.

Perhaps the most immediately recognisable and iconic works of the sixties are Bridget Riley's black and white paintings made between 1961 and 1965. Her painting has never succumbed to fashion, though the fashion world borrowed from her, and she has sustained a remarkably high level of invention within the confines of her chosen field. Whereas Riley at this time suppressed colour in her painting, fellow artists with similar concerns and also associated with what became known as "Op" art, Michael Kidner and Peter Sedgley, were concerned with exploring ways of achieving optical illusions through the transmission of pure colour. Kidner employed the repetition of simple geometric forms and colour combinations; Sedgley concentrated on merging concentric circles in order to create paintings with a highly charged kinetic intensity. Another artist who was on occasion linked to Op because of the sense of movement in his paintings was Jeremy Moon, but his interests lay in harmony and tension and he rejected the notion of a very active kind of painting.

By the mid-1960s, British art was being promoted and receiving considerable critical acclaim overseas. An important exhibition of the time was *London: The New Scene*, organised by the Walker Art Center, Minneapolis, in association with the Calouste Gulbenkian Foundation and the British Council. It was shown in five museums in the United States and two in Canada in 1965 and 1966, and featured the work of thirteen artists, eleven of whom are in the current exhibition: Blake, Cohen, Denny, Hockney, Hodgkin, Jones, King, Moon, Riley, Smith and Tilson, and six of the works were from the Gulbenkian Foundation collection. During this same period, Riley, Kidner and Sedgley were included in *The Responsive Eye*, the largest ever international exhibition of Op Art, held at the Museum of Modern Art, New York, in early 1965. Caro and many of the New Generation sculptors were then pitted against their American contemporaries in the seminal exhibition *Primary Structures: Younger American and British Sculptors*, at the Jewish Museum, New York, in 1966, and that year Caro, Bernard and Harold Cohen, Denny and Smith represented Britain at the XXXIII Venice Biennale. Two years later the honour went to Bridget Riley and Phillip King, and in 1970 Richard Smith was again selected, on this occasion for the first ever solo showing for an artist in the British Pavilion.

The two pioneering figures of the fifties, Paolozzi and Hamilton, continued to have a marked influence on what was happening in the 1960s, and their work was frequently included in exhibitions with their younger contemporaries. Although Paolozzi is considered primarily a sculptor and Hamilton a painter, a major contribution of both artists during this period was in their advancement of printmaking, in particular screen printing, then still in its infancy as a fine art medium.

Continuing to find ways of dissolving the delineation of the fine and applied arts, Paolozzi had introduced a new sculptural vocabulary

into his work by combining ready-made industrial sections with his own designs, and working with an engineering firm to produce highly finished machine-age sculpture executed in steel and aluminium (as with *Diana as an Engine I*, 1963-1966 and *Dollus I*, 1967, in the current exhibition). Recognising the same advantages could be gained by collaborating with a master-printer in the realisation of his ideas for screen printing, Paolozzi stretched the process to its limits working on suites of prints which completely encapsulated his interests in collage and modern technologies.

Hamilton's *Chicago Project* of 1969, took the notion of collaboration to an even greater extreme. Following an invitation from the Museum of Contemporary Art, Chicago, to participate in their *Art by Telephone* exhibition in 1969, Hamilton asked a young Chicago-based artist to first select the source material and then to carry out the actual production of a painting following a set of instructions delivered by telephone. The resulting painting on photograph on canvas, *Chicago Project I* (and its companion *Chicago Project II*, completed by Hamilton himself), was based on an enlarged detail from a postcard of the Prudential Building, Chicago. By handing both the choice of subject and the production of the finished painting over to someone else, in this seemingly random way Hamilton questioned the very notion of what constituted an original work of art.

The power of photography has long held a great fascination for Hamilton and his series of paintings and prints made in 1968, with the generic title *Swingeing London 67*, was to capture the pervading mood of the latter part of the decade. The original source for the series was a press photograph taken on 28 June 1967, of rock star Mick Jagger and Hamilton's dealer Robert Fraser, handcuffed together and viewed through the window of a police van as they arrived for trial on drugs charges. Hamilton's title was an ironic comment on both the so-called "Swinging London" and the nature of the punishing sentence imposed on Fraser who was imprisoned for six months for being in unlawful possession of different drugs (the sentencing judge had in fact used the term "swingeing sentence" when sending Fraser down).

As the decade drew to a close, the optimism and expectation with which it had begun had been replaced by a sense of disillusionment and introspection. The establishment which at the outset had appeared to be in step with a more progressive and enlightened society, was now retreating in the face of a new and seemingly unacceptable permissiveness. Student unrest and protest was in the air, the war in Vietnam intensified, and the 1968 Civil Rights marches in Derry marked an escalation of the conflict in Northern Ireland. The new decade of the 1970s was to prove to be the beginning of an era of hardship, recession and political strife in Britain, and it was to take another quarter of a century until there was a genuine turnaround in the country's fortunes.

Today, after a period of reflection, there is a renewed interest in and reappraisal of the painting and sculpture of forty years ago. This is not only evidenced in the number of exhibitions and publications on the art of the sixties, but importantly it is reflected in the work being made by emerging groups of artists, as they discover and take account of the invention, energy and exuberance of the art of this ground-breaking decade.

(Original text)

[1] ALAN BOWNESS, interviewed by Rui Sanchez for *A Ilha Do Tresouro/Treasure Island*, Centro de Arte Moderna José de Azeredo Perdigão, Lisbon 1996, pp. 24/65.

[2] The first use of the term "neo-romanticism" is attributed to artist and curator Robin Ironside (1912-1965), who introduced it in a pamphlet, *Painting Since 1939*, written in 1945 and published for the British Council by Longmans Green and Co., London 1947. Under a 'vague heading', John Piper, Graham Sutherland and, in his drawings, Henry Moore, were referred to as "the chief protagonists of the contemporary school", and of a younger generation of artists he listed John Craxton, John Minton, Keith Vaughan, Robert Colquhoun and Ian (Robert) MacBryde.

[3] EDUARDO PAOLOZZI, *Artificial Horizons and Eccentric Ladders*, British Council, London 1996, p. 10.

[4] There was never an official list of members, but the following names are generally credited as having been most closely associated with the Independent Group: Lawrence Alloway, Reyner Banham, Frank Cordell, Magda Cordell, Toni del Renzio, Richard Hamilton, Nigel Henderson, Geoffrey Holroyd, John McHale, Eduardo Paolozzi, Alison and Peter Smithson, Colin St John Wilson, James Stirling, William Turnbull (listed in the introduction by Jacquelyn Baqs, *The Independent Group: Post-War Britain and the Aesthetics of Plenty*, MIT Press, Cambridge, Mass., and London 1990, p. 8).

[5] WILLIAM TURNBULL, *The Independent Group: Post-War Britain and the Aesthetics of Plenty*, MIT Press, Cambridge, Mass., and London 1990, p. 195.

[6] *Tachisme* is a French term for the improvisatory non-geometric abstract art that developed in Europe, predominantly in France, in the 1940s and 1950s and was the European equivalent of Abstract Expressionism. The name derives from the French word *tache*, meaning strain or splash.

[7] Robyn Denny, interviewed by ALEX SEAGO, *Burning the Box of Beautiful Things: the Development of a Postmodern Sensibility*, Oxford University Press 1995, p. 97.

[8] *Rebel Without a Cause*, directed by Nicholas Ray, was shot in CinemaScope, a wide-screen format copyrighted by Twentieth Century Fox and first used in 1953; Paramount studios soon followed with their own wide-screen VistaVision. For a period in the mid-late 1950s, Lawrence Alloway and Roger Coleman pursued the theory of a link between wide-screen cinema and the scale of new American painting. The text of a Richard Hamilton lecture from 1960, entitled *Glorious Technicolor, Breathtaking Cinemascope and Stereophonic Sound*, is published in *Richard Hamilton Collected Words, 1953-1982*, Thames & Hudson Ltd. 1982, pp. 113-131.

[9] The term was used to describe a group of English writers whose working-class heroes shared rebellious and critical attitudes towards society. Included were playwrights John Osborne and Arnold Wesker and novelists Kingsley Amis, John Braine and Alan Sillitoe.

[10] Films and directors include: *Room at the Top* (d. Jack Clayton, 1958), *Saturday Night and Sunday Morning* (d. Karel Reisz, 1960), *A Kind of Loving* (d. John Schlesinger, 1962), *The Loneliness of the Long Distance Runner* (d. Tony Richardson, 1962), and *This Sporting Life* (d. Lindsay Anderson, 1963). The films made stars of a new generation of actors including Albert Finney, Alan Bates, Tom Courtney and Richard Harris.

[11] Speech at Bedford, England, 20 July 1957, in *The Times*, 22 July 1957.

[12] The original list of artists included: Gillian Ayres, Bernard Cohen, Harold Cohen, Peter Coviello, Robyn Denny, John Epstein, William Green, Peter Hobbs, Gordon House, John Hoyland, Gwyther Irwin, Robert Law, Henry Mundy, John Plumb, Ralph Rumney, Richard Smith, Peter Stroud, William Turnbull, Marc Vaux, Bryan Young. The organising committee comprised artists Bernard Cohen, Robyn Denny, Gordon House, Henry Mundy, Hugh Shaw, William Turnbull; curator/critics Lawrence Alloway and Roger Coleman.

[13] ROGER COLEMAN, Catalogue introduction, *Situation*, RBA Galleries, London 1960.

[14] Ibid.

[15] MEL GOODING, *Gillian Ayres*, Lund Humphries, Aldershot 2001, p. 28.

[16] In the catalogue, *New London Situation: An Exhibition of British Abstract Art*, Caro's sculpture was listed as *Sculpture I*, 1961.

[17] BRYAN ROBERTSON, *Un siècle de sculpture anglaise*, Galerie Nationale du Jeu de Paume, Paris 1996, p. 205.

[18] Annesley's *Swing Low*, 1964, Bolus's *Bowbend*, 1964, and Witkin's *Volution*, 1964, all in the current exhibition, were also included in *The New Generation: 1965.*

[19] IAN DUNLOP, *The New Generation: 1965*, Whitechapel Art Gallery, London, p.13.

[20] LAWRENCE ALLOWAY, *Young Contemporaries 1961*, exhibition catalogue, p. 3.

[21] DAVID HOCKNEY, *David Hockney by David Hockney*, Thames and Hudson Ltd., London 1976, p. 42.

[22] Boty died tragically young in 1966. She was also an actress and was screen tested for the lead role, which eventually went to Julie Christie, in John Schlesinger's 1965 film *Darling*, about a social climbing young woman in 'Swinging London'.

[23] By this time Boshier was making abstract paintings and was represented in *The New Generation: 1964* with a group of shaped canvases including *Out*, 1964, in the current exhibition.

[24] *Hayward Annual 1980: Contemporary Painting and Sculpture Selected by John Hoyland*, 29 August-12 October 1980, Hayward Gallery, London.

[25] JOHN HOYLAND, *Hayward Annual 1980*, Arts Council of Great Britain 1980, pp. 5-6.

[26] David Hockney, *Tea Painting in an Illusionistic Style*, 1961, Tate.

[27] PATRICK CAULFIELD, *Ready Steady Go: Paintings of the Sixties in the Arts Council Collection*, the South Bank Centre, London 1991, p. 21.

"UNTITLED"

ANA VASCONCELOS E MELO*

We live in the shadow of the sixties. Of all the artificial constructs by which we delineate our immediate past, 'the sixties' have the greatest purchase on the mass imagination. They stand, rightly or not, as the dominant myth of the modern era. That one might have been too old or too young to enjoy them, indeed, that one might not even have been born, is of marginal importance. Rightly or wrongly again, the great edifice casts its shadow and everything must seek its own light within it. The sixties are as much a state of mind as a chronological concept.[1]

Recently, I organised a small exhibition of works by a Portuguese artist who died very young, and who had lived in London during the second half of the sixties, while studying at the Chelsea School of Art under Patrick Caulfield (who considered him his most talented student). Since he was twenty-six when he died, his body of work, basically graphic in nature, was naturally small, and the aim of the exhibition was to explore, as far as possible, a few graphic documents and the pages of five or six sketchbooks which had been kept by relatives and friends. Besides these sketchbooks, I was able to read several of his school notes, as well as other notes of a more personal nature. And I came to realise that, in spite of the fact that I was familiar with the haircuts and clothes, and though I was able to recognise the materials, such as sketchbooks, felt-tip pens, and postcards, all those notes, that reflected the life of a young man coming out of his teens in the "Swinging London"[2] of 1967-1968, were strange to me, in their condition of snapshots of a still contemporary world, of which I had often heard, but which has mostly gone. Any historical reconstruction of that period, no matter how finely accomplished, will always be different from what we can perceive from the finished art works. The exhibited drawings have kept all their freshness, showing every sign of having been produced by a young, caustic, adventurous hand, already quite sure of the visual language it was going to explore. In a certain way, a true hand of the sixties.[3]

These considerations also apply, perhaps even more so, to many of the pieces from the sixties that are part of the British art collection of the Calouste Gulbenkian Foundation's Modern Art Centre. Almost fifty years after many of them were made, and as the body of work on their authors, time, materials and underlying ideas naturally increases, the physical reality of these pieces remains basically undisturbed, and there lies the mystery of their achievement. Their main characteristic, at least for those who deal with the collection as a whole, relates to their huge energetic potential (also present in the aforementioned drawings). This energy comes from the high quality of their execution, which had, probably, something to do with a feeling of urgency in the change that was taking place. These are, in a way, immediate pieces, aimed at visually stimulating the viewer.

It has often been said that this "theatrical and tumultuous"[4] time witnessed a real cultural revolution, in which the movements of the artistic avant-garde played a socially active role. Even though its chronological boundaries may be open to debate, London became the European centre of major cultural changes, which comprised the creation and consolidation of new artistic languages through the exploration of new communication techniques and materials. These were euphoric, dynamic and acidly humorous times, in an increasingly cosmopolitan

* Ana Vasconcelos e Melo is Curator of the Modern Art Centre José de Azeredo Perdigão (CAMJAP), Calouste Gulbenkian Foundation, Lisbon.

city, where people were becoming more and more exigent. Some of that zeitgeist lives on in these pieces. According to Arthur Danto, these "revolutionising endeavours" took on "the perspective of a utopian politics which insisted on *Paradise Now*", and no one found it strange that this cultural revolution should "be enacted in universities or in art galleries or theaters".[5] Much of the fascination these times still exert, especially among younger generations, has to do with the aestheticising of some of these characteristics. On the other hand, they look, with curiosity and probably no historic perspective, at many art pieces, magazine covers and black-and-white art documentaries from that time. At least, that was what I thought I could read on the younger visitors' faces, as they walked through *Art and the 60s. This Was Tomorrow*, an exhibition organised by Tate Britain, in the summer of 2004.

METAMORPHOSIS

Emphasising the formal diversity of the featured works, the title of one of Bridget Riley's paintings became part of the exhibition's concept itself.[6] The concept also stresses the notion of something that takes place 'beyond' form, of the need of establishing an active communication with the viewer, usually felt by these artists. This communication will take place, from now on, through features that are intrinsic to the process of making the piece, often reducing or nullifying in many works the importance of the image's content. On the other hand, their perception will change as time passes.

In the early sixties, the major innovation of British art was its open-mindedness regarding what could, or could not, be considered art. The most well-known artistic innovations of that time were associated with Pop Art, perhaps because of its visual impact and relative straightforwardness. However, not all of these pieces have adopted a conventionally 'Pop' outlook: some of them included abstract explorations, somehow invalidating the figuration/abstraction dichotomy.

These and other issues can be raised in relation to Richard Hamilton's extensive body of work, whose importance, richness and technical versatility (seen in the combination of various media, especially different printing techniques in the same piece) have made it, ever since the sixties, a continuous and stimulating source of inspiration for several artists. One of his guiding principles, since 1950, related to the dominance of each piece's guiding concept, which inexorably led him to an imagery until then totally remote from the artistic discourse.[7] And that did not mean just images that were not acknowledged as fitting a work of art, but also unprecedented artistic attitudes and practices.

Chicago Project I, from the British Council collection, was created in 1969 by a young American painter, Ed Paschke, who was following Hamilton's instructions via telephone:[8] "No one knowing Hamilton's telephoned instructions for [its] creation could have predicted that of all his works it would be one of the most formal, nor that its arrangement of distant figures amid shadows and foliage, seen beyond a looming near-vacant foreground, would so reinforce his assertion of the inherent ambiguity of photographic marks".[9] *Chicago Project II*, also from the British Council collection, is Hamilton's version of the same picture and following the same coordinates: it illustrates the artist's belief that the use of any pre-existing iconographic sources, like postcards, for instance, can be as creative as drawing something from scratch, bringing about a picture that is completely different from the image that originated it. *People*, a 1968 photogravure, is part of a series of works, begun in 1965, which explore the same concept, creating different artist-transformed pictures from the same postcard of a Northumberland beach. *Swingeing London 67 - Etching* (1968) is one of the many pieces Hamilton created from a newspaper photograph (*Daily Sketch*, 29 June 1967) depicting the arrest of Mick Jagger and Robert Fraser, Hamilton's dealer at the time, under the charge of illegal possession of several drugs. That same image received many different treatments, from posters to drawings, collages, altered photographs and prints, oil, acrylic and enamel paintings on photosensitised or silk-screened canvases, fully displaying Hamilton's skilful investigation of the original image's characteristics, as well as of its technical and visual peculiarities. Also important is the cinematic nature of this image, with all its suggestion of movement and formal analogy with a sequence of film stills.[10]

Patrick Caulfield's *View of the Bay* (1964) could also have been made from a previously existing picture, for instance a postcard depicting

a bay in some summer holiday destination. But, unlike the above-mentioned works by Hamilton, Caulfield himself composed this image, a 'view' so excessively clichéd - like other paintings of his from the same time, "which carry every association of the calendar and chocolate-box trade"[11] - that it becomes empty of content, even though the format in which it is presented identifies it as a landscape. Both technique and materials intensify the scene's lack of interest: the paint's opaqueness highlights the painting's extraordinary flatness, in which the characteristic black contouring of the figures heightens the schematic nature of the composition. This formal starkness which stresses the simplified chromatic play and the immobility of the scene, subtly contrasts with the suggestion of wind in the line of little grey flags in the foreground. The diagonal line thus created brings a discreetly disturbing note to the harmony of the whole, catching the viewers' eye and making them wonder about their position concerning the depicted scene.

Like Caulfield, David Hockney opted for combining the new artistic stance with excerpts from the past of Western art, using a figuration that is equally self-referential, though a little more personal, made up of images taken from magazines and museum catalogues. *Renaissance Head* (1963) is quite a typical painting from Hockney's early phase: in it, the seductive power of the image seems to come from the combination of *faux-naïf* drawing and the sophisticated spatial treatment of the figure and background. At that time, Hockney was especially interested in exploring the conventions and ambiguities of the representation of space, which he did in a classical way, via a thorough study of ancient paintings.[12] In 1964, at the time of the Whitechapel Gallery's *New Generation* exhibition, he stated: "I think my pictures divide into two distinct groups. One group being the pictures that started from, and are about, some 'technical' device (i.e. curtain pictures) and the other group being really dramas, usually with two figures. Occasionally these groups overlap in one picture".[13]

Hockney was briefly an abstract artist (his work as such is in the collection of Ron Kitaj, his American schoolmate at the Royal College of Art),[14] but Derek Boshier, after travelling across India in 1962, abandoned work based on figurative advertising art, an instance of which is *So Ad Men Became Depth Men*, and returned to the abstract painting he had already explored as a Royal College student, as can be seen in *Out* (1964). Boshier had grown bored with what he saw as "the tired imagery, rather trivial figurative elements and too easy, 'tender' brushwork of the 'Pop Art' manner",[15] and turned to visually striking compositions, with hard-edge patterns and powerful, contrasting colours. His interest in Richard Smith's concepts and visuals had led him to explore the magnification of images, the concept that we live surrounded by huge objects, or, in Smith's own words, "we can swim in a bowl of soup and live in a semi-detached packet of twenty".[16] Richard Smith's canvases can be seen as a "conquest of space",[17] in which the main reference is cinema, especially its Cinemascope formats. Thus they explore an approximation between the abstract and figurative languages, annulling their traditional opposition. From the mid-1950s, Smith made active contributions to the creation of a new urban mythology, by working with painter Robyn Denny and frequenting the circle of the ICA and its director, critic Lawrence Alloway. One of the most interesting aspects of his oeuvre is the fact that he kept creating abstract works - which, together with works by other artists, were featured in exhibitions like *Place*[18] (ICA, 1959) or *Situation* (RBA Gallery, 1960) - while never forsaking his interest in the representation of objects and things that communicated with the observer in a more immediate way. This is quite clear in *Package* (1962) and *The Lonely Surfer* (1963), works that can be described as Abstract Pop. Regarding the size of his paintings and the internal and external spatial repositioning of his work, Smith liked to quote Rothko, who said he painted large canvases because he wanted to be intimate and human, because he wanted to be on the 'inside' of the painting, without controlling its development. This new approach seduced several painters, and was also at the source of the profound change that took place in sculpture.

The notion of sharing the physical space of the work of art with the viewer entirely changed the conditions of its reception and was especially felt in the realm of sculpture. In 1959, Anthony Caro's two-month trip to the USA led to a complete modification of his sculpture: he stopped modelling human figures and started creating abstract sculptures, made of joined metal elements. As can be seen in *Pink Stack* (1969, British Council collection), Caro placed his sculptures on the ground, doing away with the plinth that distanced the work from the viewer's space and body, bringing about a new rapport, not only with the surrounding space, but with the very ground on which they lay.

The introduction of colour is another fundamental element, giving the works increased lightness and a new communicability. Caro influenced several of his students at St Martin's School of Art, which eventually became known as the New Sculpture Generation, after the name of the exhibition held in 1965 by the Whitechapel Gallery.[19] *Ripple* (1963) is a typical sculpture by Phillip King. It can be described as an ambiguous, organic shape, in a vertical disposition that is somewhat precarious and visually unbalances the viewer. The undulating shape and the colours of the plastic show the influence of Matisse, an artist who is also very present in Caro's work.[20] The abstract language of these pieces makes them more accessible to viewers, in the sense that they are able to recognise primordial shapes with which to identify. The domestic scale of Annesley's *Swing Low* (1964) situates that sculpture within everyday life.[21] The steel takes the form of an undulating line that cuts through a square, before fixating itself on the floor (the square is only poised on one of its corners). Michael Bolus' *Bowbend* (also 1964) is a 'hard-edge' three-dimensional 'painting', displayed below eye level.

The painters who, in 1960, brought their large abstract works to the first *Situation* exhibition, wished to stress the sculptural, object-like dimension of their paintings, not only through their material qualities – every visible inch of their stretched but unframed canvases was painted – but also through the spatiality they created, enveloping the viewer as a temporary architecture.

The *Situation* painters included Robyn Denny, Bernard Cohen, John Hoyland and Gillian Ayres. These artists defended a purer, more urban abstraction,[22] rejecting the landscape-based abstraction that had been developed by the older abstractionists of the St Ives School.[23] An essential element in observing these paintings was optical proximity,[24] which led the viewer to scan them physically, moving more the neck than the eyes. Here we find again Rothko's words, as reformulated by Lawrence Alloway: "An awareness of the world as something that contains both the work of art and the spectator (rather than the romantic notion of the work of art itself as a world) is at the core of the recent developments in London."[25] Of course, there are also differences between these abstract works, even though they somehow share common interests and procedures: large format, spatial investigation, objectification of the work, kind of communication established.

Send Off (1962), by Gillian Ayres, displays a more gesturalist approach and explores the very nature of painting, as the markings on the canvas create a picture and their own space, "perhaps like a space a sailor of Magellan's would have felt when the world was flat and he had sailed off the edge".[26] This same notion of 'sailing off' a habitable, familiar space can also be found in Robyn Denny's work, even though in reverse, since our gaze is now focused inside the canvas. *Jones' Law* (1964) is part of a series of works, begun in 1961, which presents the same formal motif, a passage- or door-like design in the centre of the canvas. This point may act as "a dramatisation of the X where spectator and artwork meet"[27] –, and here it has been geometrically fragmented: "Hidden within *Jones' Law*, is a set of diminishing rectangles whose edges are at times invisible but can be deduced by sudden cut-offs and obscurings of continuity. The surface [...] is divided into shapes where each edge suggests the overlap by one plane of another, and though there is still the appearance of a strong linear activity, the painting only makes perceptual sense as an illusion in depth".[28] The representation of such non-Euclidean limits also took its inspiration from science fiction literature.

For Bernard Cohen, painting meant taking committed action against the void, by assuming an existential pledge without which there could be no artistic development. *Mist* (1963) is already quite a different picture from those he had presented at the *Situation* exhibitions, having already abandoned formal geometric unity, in favour of a cartographic or diagrammatic treatment of the picture plane. Cohen creates a purely intentional, "to show things to be seen"[29] painting, which can be interpreted by analysing its contents. For him, the image was a container in which the modulated surface could take on several decipherable meanings, in accordance with an interpretative key to the picture's structure.

John Hoyland took part in the *Situation* exhibitions and also in the already mentioned, and quite celebrated, *New Generation*. After finishing his course at the Royal Academy Schools, in 1960, Hoyland had gone from a first stage of his studies, concluded in 1956, in which he had learned nothing about abstract art, to becoming one of the most important abstract artists in London.[30] *No. 19, 26.12.1961* explores the symmetry of the figure and the background itself in relation to the canvas' upper and lower halves, by simply changing the colours of the

figure's outline, which appears as a vertical structure, half-seen against the velvety blue of the background. *8.8.63* also characteristically divides the field of vision, not into two halves now, but into two basic elements of an intense pink, united by an undulating green patch that seems to drip and turns into blue, at the lower right corner: "[…] it was not till August 1963 that […] he felt able to achieve a 'simple' painting again in which the colour was properly dictating the form, and the forms were not ranging themselves in depth because the colour was acting like tone […]. In his new work, the expression is boldly intuitive, the configurations personal and unpredictable, the colour less romantically ominous, higher-pitched and more adventurous than anything he has achieved hitherto".[31]

Bridget Riley, who had also participated in *New Generation: 1964*, became associated to what would come to be known as Op Art (this term was coined by the British press that very year), even though her position as an artist is quite independent from the developments in British art during the 1960s. In her black and white paintings, created between 1961 and 1965, she explored movement, suggested by the different rhythms given to certain elements, like triangles or ovals. In *Metamorphosis* (1964) Riley operates on the level of the optical ambiguity generated on the spectator through the suggestion of progressive dislocation of grey dots impeccably painted on a pure white background. *Shuttle 1*, from the same year, is a structure of ten undulating stripes, traced with black and white inverted diagonals (there is no figure/background separation), which create a multi-focalised space. These visually complex figures appeared intuitively: there are no mathematical elements in Riley's paintings. As the artist herself said: "The basis of my paintings is this: that in each of them a particular situation is stated. Certain elements within that situation remain constant. Others precipitate the destruction of themselves by themselves. Recurrently, as a result of the cyclic movement of repose, disturbance and repose, the original situation is re-stated".[32]

Howard Hodgkin's work is apparently unrelated to all other pieces presented so far, and yet, judging from his many portraits of couples from the British artistic milieu of the sixties - ironically described by his friend Bruce Chatwin as "portraits of forlorn married couples in closed rooms",[33] which include *Mr and Mrs Patrick Caulfield* (1967-1970) -, he always kept in touch with the most well-known and prolific artists of that decade. His sixties paintings blended or, perhaps more accurately, conciliated abstract and figurative elements, taken from such sources as Pointillism, Hard-Edge and Pop, while trying to capture the psychological moods of certain groups of people. Again in Chatwin's words, Hodgkin "seems incapable of starting a picture without an emotionally charged subject, though his next step is to make it obscure, or at least oblique".[34] Yet, some of the portrayed were able to recognise themselves intuitively,[35] through the colours and shapes the painter had used, without needing to read the title. Concerning his unique oeuvre, Hodgkin wrote the following: "My subject matter is simple and straightforward. It ranges from views through windows, landscapes, even occasionally a still life, to memories of holidays, encounters with interiors and art collections, other people, other bodies, love affairs, sexual encounters and emotional situations of all kinds, even including eating. From this incomplete and random list it's clear that even in human terms some of these situations would be more veiled […] than others. All these subjects have one thing in common - seen through the eyes of memory they must be transformed into things, into pictures using the traditional vocabulary of painting, where scale and illusionism, among many other ingredients, play their part."[36]

THE COLLECTION

Metamorphosis is more than a celebration of a particularly fertile and diversified period of twentieth-century British art: it also marks the temporary reunion of two collections that shared a common history during these same years. In 1959, the Calouste Gulbenkian Foundation gave its first grant to the British Council, for the acquisition of contemporary British works of art. These acquisitions were made in the same way as all other British Council purchases, that is to say, through the director of that institution's Fine Arts Department, following the recommendations of a consulting committee that included such illustrious names as Herbert Read, Roland Penrose or Alan Bowness. Though property of the Calouste Gulbenkian Foundation, the purchased works were to be used by the British Council for ten years, during which they were exhibited in the institution's British art and culture promotion programmes (several international travelling exhibitions, decoration of the British Council's offices in the UK and abroad). In 1964, there was a new grant, in the same terms as the

first. Since that time, the purchases of British art have diminished, even though they have continued irregularly until the present day, and are now carried out by several experts, chosen by the UK Branch of the Calouste Gulbenkian Foundation.

The first grant conferred to the British Council was used to buy paintings, drawings and some reliefs, especially works by young British Pop artists like Peter Phillips, Peter Blake, David Hockney, Allen Jones or David Smith, or *Situation* figures like Robyn Denny, Bernard Cohen, Gillian Ayres or John Hoyland, and also various paintings and reliefs by Joe Tilson, made between 1959 and 1962. The nine Tilson pieces bought between 1960 and 1963 – four paintings, three from 1959 and one from 1960, and five 1960/1963 reliefs – are a good example of how these purchases were often exhaustively carried out within the work of a single artist, and often in the very year the pieces had been made. On the other hand, many of these pieces, as far as we can verify from the British Council's registers, were immediately put into the itinerant exhibitions. Two of Tilson's reliefs, bought in November 1962, travelled to Japan in January 1963, as part of the *7th International Art Exhibition*, which would later that year travel across Australia. A busy life!

The second grant, conferred in 1964, was especially dedicated to the purchase of sculptures. It was then that works by the New Generation sculptors were bought, though some important paintings were also acquired, like the works by Patrick Caulfield, Antony Donaldson, or Derek Boshier (in his Op phase).

Even the most cursory glance across these works will reveal that most of them were bought from very young artists, who had recently finished art school and were taking part in exhibitions that would prove historical in terms of revealing the new 1960s generation, like the annual *Young Contemporaries*, or the two *New Generation* exhibitions, organised by the Whitechapel Art Gallery in 1964 and 1965. The impact of the *New Generation: 1964* exhibition on London's art world and on the definition of our collection can be gauged from the fact that ten of the twelve artists featured there are also present here, and it was equally there that paintings like Bridget Riley's *Shuttle 4*, Allen Jones' *"Dance with the Head and the Legs…"*, Peter Phillips' *INsuperSET* and Derek Boshier's *Out* were bought.

Even while the works were still based in the UK, some of them paid a visit to Lisbon. In 1962, the British Council held an exhibition at Sociedade Nacional de Belas Artes, in which eight pieces were presented already bought for the Calouste Gulbenkian Foundation. Two years later, Gulbenkian's Arts Advisory Committee in the UK organised a great international exhibition, *Painting and Sculpture of a Decade: 1954/1964*, at the Tate Gallery, which included works from the Foundation's British art collection in a broad selection of American and European contemporary artists. In January 1971, the ten years loan to the British Council came to an end, and the Calouste Gulbenkian held in its Lisbon premises an exhibition entitled *100 Obras de Arte Contemporânea da Fundação Calouste Gulbenkian* [100 Contemporary Art Pieces of the Calouste Gulbenkian Foundation]. Some of these works were again presented to the Portuguese public in July 1981, to mark the Calouste Gulbenkian Foundation's twenty/fifth anniversary, in an exhibition that anticipated the inauguration of the Modern Art Centre, fittingly entitled *Antevisão do Centro de Arte Moderna* [A Preview of the Modern Art Centre]. In July 1983, the pieces were shown at the recently inaugurated Modern Art Centre. In 1996, the Modern Art Centre exhibited its collection of British drawings and, in 1997, held the *Treasure Island* exhibition, which combined works from the collection with many loans from the UK, to present what would be the ideal British modern art collection in the minds of the exhibition's curators, Jorge Molder, director of the Modern Art Centre from 1994 until the present day, and Rui Sanches, then Assistant Director of the Centre, a sculptor who had studied at Lisbon's Fine Art School and at London University's Goldsmith's College.

Thus is briefly sketched the itinerary of the Calouste Gulbenkian Foundation's British art collection, which has found, in *Metamorphosis*, the perfect opportunity for reuniting with art works with which it shares a lively past. We hope that, in the future, there will be other occasions in which the two collections and the people behind them will be able to work together as joyously as in the present one, offered to us by the Basil and Elise Goulandris Foundation.

(Original text)

[1] JONATHAN GREEN, *All Dressed Up, The Sixties and the Counterculture*, Pimlico, London 1999, p. IX.

[2] "*Time* magazine of 15 April 1966 had published an article, advertised on the cover by the phrase 'London: The Swinging City', which purported to document a snowballing social revolution towards light-hearted permissiveness centred on London, and gave international currency to the phrase 'Swinging London' from which Hamilton's title is derived." RICHARD MORPHET, *Richard Hamilton*, Tate Gallery, London 1970, p. 78.

[3] The artist was Ruy Leitão. This was his second exhibition at the Calouste Gulbenkian Foundation.

[4] ARTHUR DANTO, *Beyond the Brillo Box. The Visual Arts in Post-historical Perspective*, University of California Press, Berkeley/Los Angeles/London 1992, p. 3.

[5] ARTHUR DANTO, *Beyond the Brillo Box* cit.

[6] The exhibition's title was suggested by Richard Riley.

[7] RICHARD MORPHET, "Introduction", in *Richard Hamilton*, Tate Gallery, London 1970, p. 8.

[8] "Get a coloured postcard in the Chicago area of a subject in Chicago. Either get it yourself or, if you are worried about the aesthetic responsibility of choosing something, ask a friend to provide it. Take a piece of paper and cut a hole in it 1" high by 1½" wide. The hole should be square with a corner of the paper, 1" to the left of the edge and ¾" from the bottom edge. Place this in the bottom right hand corner of the postcard. Get a photographer to enlarge the area of the postcard revealed in the hole to a size of 2'8" x 4', preferably on sensitised canvas but if this isn't possible have a paper print dry mounted on hardboard (Masonite). Leave 20% of the surface untouched black and white. Paint 40% in roughly the colours apparent in the postcard. Paint 40% in complementaries of the colours that appear in the postcard. Either transparent stains or opaque colours, some thick, some thin, which areas are at your discretion" (*Richard Hamilton* 1970 cit., p. 84). The piece was made for the *Art by Telephone* exhibition, organised by Chicago's Museum of Contemporary Art in late 1969.

[9] *Richard Hamilton* 1970 cit., p. 84.

[10] *Richard Hamilton* 1970 cit., p. 78.

[11] DAVID THOMPSON, *The New Generation: 1964*, Whitechapel Gallery, London 1964, p. 19.

[12] This *Renaissance Head* is the result of the study of a series of paintings of the same subject, a profile of a male bust under an arc, on which Hockney had probably been working since his days as a student. I recommend his book *Secret Knowledge. Rediscovering the Lost Techniques of the Old Masters*, Thames & Hudson, London 2001.

[13] David Hockney in THOMPSON, *The New Generation* cit., p. 40.

[14] "During our first days at the Royal College I spotted this boy with short black hair and huge glasses, wearing a boiler suit, making the most beautiful drawing I'd ever seen in an art school. I told him I'd give him five quid for it. […] I kept buying drawings from him. I've still got them all. I've even got a very rare Hockney abstraction from his two-week abstract period." Kitaj

statement in *David Hockney. A Retrospective*, Los Angeles County Museum of Art and Thames & Hudson, Los Angeles/London 1988.

[15] Quoted in THOMPSON, *The New Generation* cit., p. 12.

[16] "The scale of the painting is often physically related to hoardings or cinema screens which never present objects actual size; you could drown in a glass of beer, live in a semi-detached cigarette pack." *Living Arts*, no. 1, 1963, in DAVID MELLOR, *The Sixties. Art Scene in London*, Phaidon Press, London 1993, p. 130.

[17] In MELLOR, *The Sixties* cit., p. 64.

[18] The paintings were hung near the ground, thus acting as cinema screens.

[19] Of the nine sculptors featured there, six had studied under Caro - Tim Scott, Phillip King, David Annesley, William Tucker, Isaac Witkin and Michael Bolus.

[20] MARCELIN PLEYNET, "L'Europe avec et sans l'Europe: Caro et King dans les années 60", in *Un Siècle de Sculpture Anglaise*, Galerie National du Jeu de Paume, Paris 1996, pp. 195-202.

[21] PENELOPE CURTIS, *Modern British Sculpture from the Collection*, Tate Gallery, Liverpool 1988, p. 114.

[22] ALAN BOWNESS, *A Ilha do Tesouro*, Fundação Calouste Gulbenkian, Lisbon 1997, p. 25.

[23] Some of these 'first' abstractionists had been responsible for the divulgation, in London, of post-war American art trends, namely Abstract Expressionism, Action Painting and post-painterly abstraction.

[24] In MELLOR, *The Sixties* cit., p. 80.

[25] LAWRENCE ALLOWAY, "Illusion and Environment in Recent British Art", *Art International*, Feb 1962, p.38, in MELLOR, *The Sixties* cit., p. 80.

[26] Artist's statement, quoted in MELLOR, *The Sixties* cit., p. 29.

[27] LAWRENCE ALLOWAY, "Robyn Denny", Molton Gallery, Nov/Dec 1961, quoted in MELLOR, *The Sixties* cit., p. 80.

[28] DAVID THOMPSON, *Robyn Denny*, Penguin Books, Middlesex/Baltimore/Victoria 1971, p. 33.

[29] David Mellor interviewing Bernard Cohen, 11.10.1991, in MELLOR, *The Sixties* cit., p. 113.

[30] In THOMPSON, *The New Generation* cit., p. 43.

[31] In THOMPSON, *The New Generation* cit., p. 44.

[32] BRIDGET RILEY, "Perception is the medium" [1965], in ROBERT KUDIELKA (editor), *The Eye's Mind: Bridget Riley. Collected Writings 1965-1999*, Thames & Hudson, London 1999, pp. 67-68.

[33] BRUCE CHATWIN, *What Am I Doing Here?* [1989], Vintage, 1998, p. 77.

[34] In CHATWIN, *What Am I Doing Here* cit., p. 78.

[35] MICHAEL AUPING, "A Long View", in *Howard Hodgkin Paintings*, Modern Art Museum of Fort Worth, Texas 1995, p. 14.

[36] HOWARD HODGKIN, letter to John Elderfield, 2 February 1995, in *Howard Hodgkin Paintings*, 1995 cit., p. 69.

WHY AN EXHIBITION OF BRITISH ART FROM THE 1960s?

ISADORA PAPADRAKAKIS*

One could argue that art is always self-referential, in a constant dialogue with itself; that it exists in the past as well as in the present and for the future. Indeed, the essence of the twentieth-century avant-garde myth was rooted on the artist as a precursor, he who prepared the future whilst rejecting the past. The 1960s challenged that myth and, since then, post-modernism has done a lot to render its assumptions obsolete. An exhibition about that decade now has as much to do with our current sense of popular culture as with art itself. Especially the swinging British sixties have become a brand permanently in vogue, one that lends itself to myriads of contemporary reinterpretations in the realms of fashion, advertising, industry and cultural theory, to name a few.

In 1961, the philosopher Theodor Adorno opened his *Aesthetic Theory* with the following statement: "Today it goes without saying that nothing concerning art goes without saying". 1961 was the year JFK was elected President of the US, the Berlin wall was constructed and Yuri Gagarin orbited the earth. It was the beginning of a decade when all previous assumptions about the relationship between art and culture where to be put to a very public test. Following the tortured, epic expressionism of the 1950s and preceding the distanced cerebral conceptualism of the 1970s, the 1960s in global art terms could be described as an explosion - albeit a measured one - between two introspections. The evolution of art in Guy Debord's "age of the spectacle" was not as heroic as the forward march of modernism. Yet, it did signify an era of transformations: the world moved from the cult of the genius as being the only truly validating excuse for making art, to the cult of mass culture; from art as the property of an elite, to art as professing to exist in and for the popular sphere; from questioning the form of the artwork to interpreting it as a set of ideas on how to perceive the world; from singular images to schematic signs; from the rarefied hierarchy of high culture, to low-cultural alternatives multiplied; from Jackson Pollock's "I want to be like nature", to Andy Warhol's "I want to be a machine".

Moreover, the 1960s were, to borrow from the emblematic Yves Klein happening, a leap into the void: an era suspended between the afterglow of modernism and the birth of post-modernism. Those artists and theoreticians challenging the modernist account of art history identified with US critic Clement Greenberg, began to seek the meaning of the artwork not necessarily within it but in the context within which it existed: the socio-political universe it quite literally appropriated.

Art in Britain did not exist in a vacuum. With the communications explosion accelerating the dissemination of information as it did, borders and boundaries were transcended at a speed never before experienced. In 1962, telecommunications satellite Telstar conveyed the first direct transmission of TV images from the US to England. In 1963, Marcel Duchamp - arguably the father of the European avant-garde - had a retrospective exhibition in Pasadena, Texas. In 1964 - just as Beatlemania was sweeping the US - American artist Robert Rauschenberg won the Grand Prize at the Venice Biennale, prompting the Vatican Newspaper *L'Osservatore Romano* to denounce the award as "the total and general defeat of culture". The particular irony of the statement lies in that, far from being the end of culture, this was art that spoke directly for mainstream culture. The popular press, Technicolor and widescreen film, billboard extravaganzas and television, produced universal imagery that had to be noticed, simultaneously, on both sides of the Atlantic.

* Isadora Papadrakakis is Head Creativity and Society, British Council, Greece.

In making reality noticeable, Roy Lichtenstein, Richard Hamilton, Robert Rauschenberg and the more overtly political Wolf Vostell, Sigmar Polke, Gerhard Richter and Robert Hains, all magnified the banality of its signs; in addressing the cynicism of consumer culture, they brought forth an ideology of art as a commodity; in celebrating reproduction and multi-unit production processes they demystified the artist's gesture; in juxtaposing Mickey Mouses and napalm-bearing fighter planes, they exposed the vacuum of political iconography and, more importantly, self-referentially highlighted the fact that mass media took away their own political speech. Much of the decade's art production which now appears somewhat dated was then a slap in the face: the same mass culture it celebrated it also undermined. Jasper Johns - who reproduced the American flag on canvas - called his imagery "things the mind already knows" and then proceeded to deconstruct this knowledge.

Roland Barthes in his *Mythologies* (1957) devotes a whole chapter to plastic. "Plastic", he writes, "is the first magical substance which consents to be prosaic. But it is precisely because this prosaic character is a triumphant reason for its existence: for the first time artifice aims at something common not rare". And, for the first time, art aimed at rarefying the common. In France, half a century after Marcel Duchamp displayed a urinal to the world, artists and theoreticians ventured into questioning the uniqueness of the object. The Nouveau Realistes - Pierre Restany, Arman, César, Niki de Saint Phalle, Yves Klein, Jacques de la Villeglé - incorporated the *objet-trouvé* into the artwork. Only, in contrast to Duchamp's ready-made, they treated mass-produced images as cultural objects. The found object became an emblem of the culture which produced it; it no longer appeared to bask in its esoteric nature but on the contrary, to borrow its existence from the most accessible facets of the everyday.

Much like Minimalism, Situationism, Fluxus, Op Art and Nouveau Realisme, Pop Art turned its back once and for all on the philosophy of western rationalism, its falsification of reality. Things must be as they appear to be; namely, in Richard Hamilton's famous words of 1957, "Popular, Transient, Expendable, Low-cost, Mass-produced, Young, Witty, Sexy, Gimmicky, Glamorous, Big business". Yet, in appropriating the brave new world of marketing, art self-consciously promoted itself as a brand: the establishment's very own marketable face. As Robert Hughes pointed out in *Shock of the New* the sudden rush of art investment gave birth to the two guiding superstitions of the decade: the notion of artistic validation through getting and holding the attention of the media; and the notion of art in the limelight, the artist as an overnight star, the rush to get known fast, that fifteen-minute perishable slot in the machine of fame.

This was art that existed for an audience, just as the meaning of the artwork was dependent upon the experience of the person viewing it. When Andy Warhol proclaimed that he wanted to be a machine, he essentially identified himself with cheap, deliberately blank consumer culture. In Hughes' words: "Warhol's surfaces want to be glanced at like a TV screen - not scanned like a painting". The viewer was urged to move from being the mindless consumer of messages to being an empowered interpreter of signs. In repackaging the familiar (adverts, comic strips, domestic appliances, science fiction, movie stars, newsreels) art may have conveyed its instantly digestible face directly to the public, but there was a flipside: those signs could only differentiate themselves from the vast, mass-media produced universe of the real world, if they placed themselves on the pedestal they so wished to subvert. Art of this kind could not survive outside a museum, since any contact with that message-crammed universe would at once render it impotent.

However, in an unprecedented move, Art subverted its image(s) and called this act of subversion 'art'. When asked by Brian Glazer why he wanted to avoid compositional effects, Donald Judd, one of Minimalism's most influential exponents, replied: "Those effects carry with them all the structure, values, feeling of the whole European tradition. It suits me fine that it's all down the drain". Judd evoked the 'drain' on behalf of a whole generation of artists who - beyond geographical borders and formalist restrictions - were all reacting to the popular, transient, expendable, low-cost, mass-produced, young, witty, sexy, gimmicky, glamorous, big business of the Here and Now.

Metamorphosis is not a retrospective; it is not even an overview. An age of pluralism, so laden with political - in the widest sense of the word - signs and symbols, is very difficult to capture within a museum space. This exhibition very selectively spans a Collection and sheds light

on the co-ownership of its identity by two institutions, the Gulbenkian Foundation and the British Council. The fact that most of the works on display were purchased between 1959 and 1964, gives them an air of authenticity which in a way strips them of being relics of the past: they were selected then as documents of a very vibrant present.

It is also an exhibition which marks the collaboration of three European institutions, for the first time bringing together the Goulandris Foundation of Greece, the Gulbenkian Foundation of Portugal and the British Council.

Therefore, *Metamorphosis* derives its *raison d'etre* from its context, as well as from its content: the cross-cultural creative process which made it happen.

The British Council would like to thank all those who so successfully collaborated across our three countries to complete the *Μεταμόρφωση* (metamorphosis).

(Original text)

WORKS

David Annesley

The younger generation of British sculptors of the 1960s includes David Annesley, Michael Bolus, Phillip King, Tim Scott, William Tucker and Isaac Witkin, who studied at St Martin's School of Art under the supervision of Anthony Caro and who participated in the 1965 *New Generation* exhibition held at the Whitechapel Art Gallery. Encouraged by Caro's own practice, they tended to reject traditional methods and created works using new materials: steel, as well as plastic and fibreglass.

New Generation sculptors made use of vibrant colours and created works whose dimensions did not exceed human measure. They showed an interest in approaches formulated by avant-garde British sculpture of the 1950s, which sought to trace a new relationship between sculpture and everyday experience in large urban centres. They turned their back on the melodramatic images produced by sculpture of the post-war period.

Influenced by Caro, Annesley uses independent parts, whose form is clearly defined and which are animated by means of colour, to construct abstract compositions that are then placed directly on the ground without a base, thus articulating a complex relationship between the viewer's space and the space occupied by the sculpture. His sculpture is purely self-referential, released from all references that might exist outside its own context.

He created his first works by welding metal parts together, using various materials found on construction sites or scrap metal warehouses and junkyards. Some of his works incorporated steel parts that were often painted black. He soon realised that he preferred to create structures rather than carve material into a certain shape. Metals - steel in particular - allowed him to achieve the desired effect: a combination of rigidity and suppleness. Annesley considers metal to be a material offering a wide range of uses, whose diverse possibilities might readily fulfil the functional needs of sculpture.

In bold, linear works, such as *Swing Low*, relationships between form and colour acquire a three-dimensional character. This work, which is a paradigm for the period in question, is created on a human scale, a characteristic element of the artist's work after 1961. Its total length matches that of the artist's arms when extended. The abundance of colour is in accordance with the wave-like form of the composition's middle part, which is harmoniously complemented by two identical metal parts.

Painting gradually acquired significance in Annesley's work and the artist eventually dedicated himself to it from the late 1960s onward. In *Untitled* one may discern one of the features that also seems to characterise his sculptures, namely a variety of colours, which serves to highlight and animate his work. Combination and contrast are achieved through a striking diversity of design and colour. Dots and broken or undulating lines of various sizes create a multicoloured roar, a celebratory image of art and inspiration.

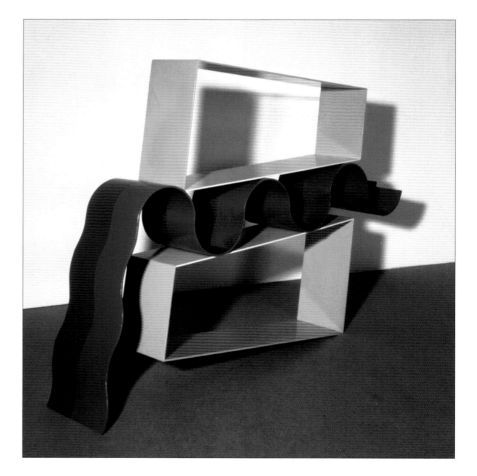

Swing Low

1964
PAINTED STEEL
129.5 X 162 X 30.5 cm
COLL. CAMJAP/CALOUSTE GULBENKIAN FOUNDATION, LISBON

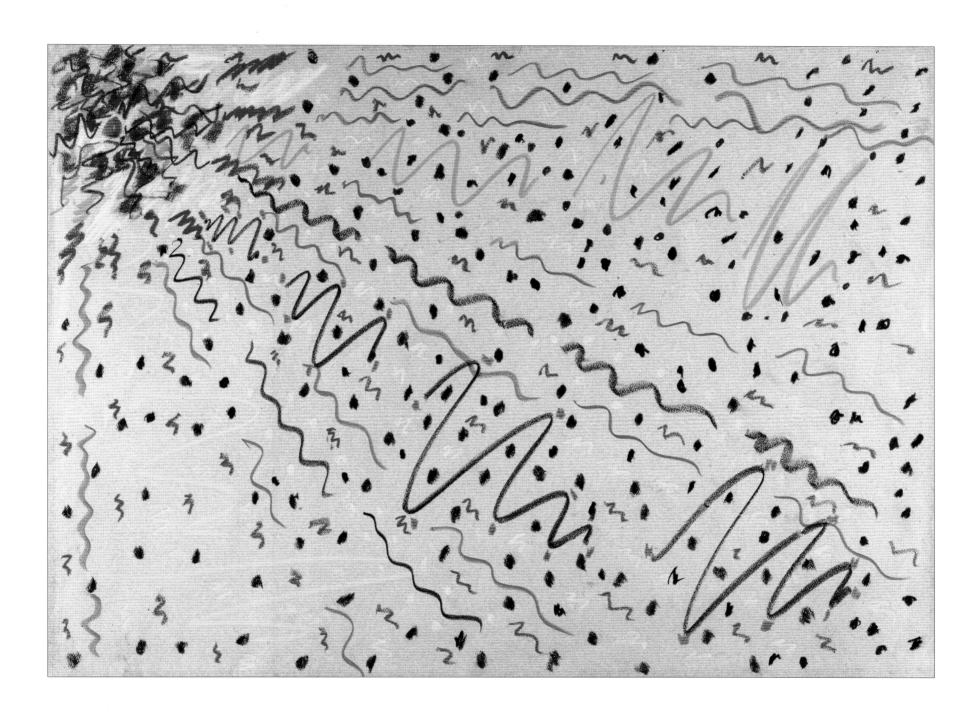

Untitled

c. 1962
PASTEL ON PAPER
55 X 75.4 cm
COLL. CAMJAP/CALOUSTE GULBENKIAN FOUNDATION, LISBON

Gillian Ayres

Ayres was closely involved with British representatives of abstract art, as well as with Roger Hilton. At the same time, her work was influenced by European *art informel*,[1] as well as by American Abstract Expressionism. The abstract works she has created possess a clearly personal quality, which grants her a special place among artists of her generation.

Among the work of her contemporaries, Ayres placed emphasis on Roger Hilton's 'free abstraction', Hilton being the first with whom she discussed her own work. Jackson Pollock's handling of colour also had a profound influence: that is, colour applied directly, without the use of a paintbrush, on the surface of a canvas lying on the floor. Ayres herself began to paint without a paintbrush, using the body's movements, free from the conventional set of gestures allowed by the presence of an easel.

At the beginning of the 1960s she was the only woman artist in London to participate in the important exhibitions of the Situation Group, with large-scale abstract works intimating a delicate, impulsive approach to the act of painting. She combined the use of oil pastels with that of paints used in the painting of houses. The latter helped the dripping and pouring involved in the technique of Action Painting occur in a more natural way. Her use of colour was instinctual, but the density of the stroke did not compromise each colour's particular accuracy and clarity so that Abstract Expressionism was allowed to reclaim its eloquence, free from all that is melodramatic.

Ayres' work has been marked by diversification in terms both of the means of expression and of visual style. After 1959 she began to abandon the technique of Action Painting and to use the paintbrush instead, with which she created a considerable number of different

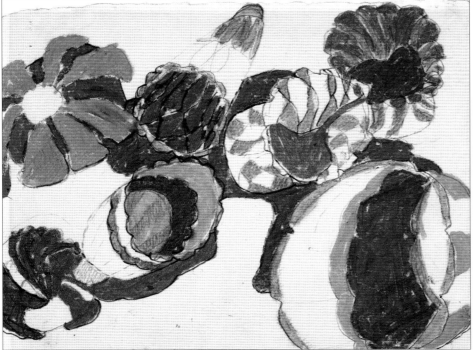

Untitled

1965
FOUR OIL CRAYON DRAWINGS ON PAPER
FRAMED TOGETHER
55 X 53 cm
COLL. CAMJAP/CALOUSTE GULBENKIAN FOUNDATION, LISBON

forms and figures. Later works acquired a more intense rhythm and colour, while the structure of images was different. During the 1960s she created attractive decorative images that preserve the era's hedonistic mood, but in the 1970s she returned to an extreme, often strict abstraction. At the end of the decade and under the influence of Hans Hoffmann's painting, she returned to oil painting, developing a distinctive style that was both colourful and suggestive and creating some of her most delightful images.

In *Send Off* one may trace Ayres' typical untroubled approach to painting: circular forms in intense colours set against a neutral background impart an airy sense to the work and outline the contrast between the material and the immaterial. Her work diverges from that of the rest of the artists in the Situation group and from their extremely polished style of abstraction.

In *Stamboul* the viewer is allowed a glimpse of the chaotic but at the same time magical image projected by the cities of the Orient. Ayres continues to play with form and colour; cold blue and warm red evoke melodies and scents and harmonise with curves and linear forms that captivate the eye.

In the four 1965 *Untitle*d drawings we may trace that natural, unaffected liveliness and energy so typical of her work, as well as the balance between materials, form and colour. These works are tangible and, despite the overwhelming presence of pigments, still breathe and glow.
Although her works seem to have been the result of a spontaneous, effortless act ⁄ indeed each painting's completion requires a considerable amount of time ⁄, each stroke has entailed careful thought and in many cases the paintings have been reworked over and over again before they acquire that lush and polished surface that is so characteristic.

[1] *Informel* art: the term is used to define all painting practices appearing in post-war France, with the exception of 'constructed' abstraction that follows the tradition of Mondrian and the *De Stilj* magazine, which would eventually lead to kinetic art. The homogeneity of these practices lies in their impulsive gestural quality which borders on calligraphy, in the use of an expressive study of materials and most importantly in the rejection of clear representation. *Informel* art does not thoroughly depart from a realistic context of references (i.e. the work's title) and does not question anew the painting's identity or the conventional norms of presentation and production, which was first attempted by American artists.

Gillian Ayres

Stamboul

1965
ACRYLIC ON CANVAS
122.5 X 122.5 cm
COLL. CAMJAP/
CALOUSTE GULBENKIAN FOUNDATION,
LISBON

Send Off

1962
OIL ON CANVAS
213 X 305 cm
COLL. CAMJAP/
CALOUSTE GULBENKIAN FOUNDATION,
LISBON

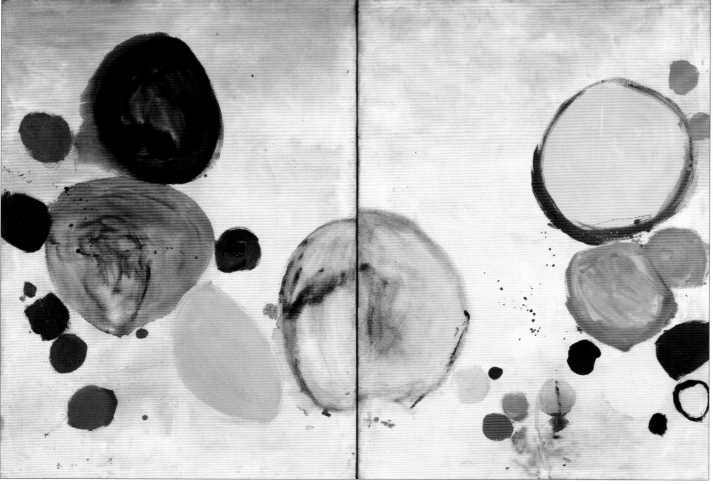

Peter Blake

Peter Blake was a leading exponent of British Pop Art. His work incorporated the iconography of contemporary culture: his images directly referred to the world of comic-books, consumer products and advertising. The source of his subject matter was always to be found in the world around him. His early Pop works and collages featured images associated with the interests of a boy belonging to the working class who saw a lot of movies during the late 1930s and throughout the 1940s: images of Tarzan, Jean Harlow, the royal family; images from the world of the circus and the world of boxing; characteristic female figures in bikinis. Later on his work would also include figures such as the Beatles, Elvis Presley, presidents Mitterrand and Reagan, as well as Margaret Thatcher. From 1959 he began to create works using collage and featuring pop-musicians, movie stars and pin-up girls. His early Pop works incorporated several naturalistic and autobiographical elements. Blake opted for a game between the processes of the image's construction and deconstruction, as well as for the use of numerous collages based on material he gathered during his trips to Europe (postcards and pictures from magazines which he then applied on objects he had found or made and which he painted with bright colours). The particular vocabulary that reflected the spirit of Pop Art is manifest in these collages.

Blake presents himself as an insatiable consumer and collector; a man who collects magazines and frequents antique shops for the purpose of gathering images and various objects. Thus he chooses to place himself directly in the vortex of his era's visual culture rather than to merely observe popular tastes from the artist's high throne. He acknowledges no dividing line between his choices as a person and his role as an artist. Blake attempts to depict in his practice the experience of the average consumer of popular culture. This particular characteristic distinguishes his work from that of other Pop artists, who seem to be placing emphasis more on a sophisticated analysis of forms of mass communication.

Five pencil drawings on paper

FRAMED TOGETHER

Bertram Mills
1961
PENCIL
21.5 X 12.6 cm
BRITISH COUNCIL

Bertram Mills
1961
PENCIL
28 X 20.3 cm
BRITISH COUNCIL

Jimmy Scott, Bertram Mills
1961
PENCIL
21.5 X 13.3 cm
BRITISH COUNCIL

Bertram Mills
1961
PENCIL
21 X 21.5 cm
BRITISH COUNCIL

Bertram Mills, Circus Season
1967
PENCIL
23 X 15 cm
BRITISH COUNCIL

Peter Blake

His most well-known work is the cover of the Beatles' *Sergeant Pepper's Lonely Heart Club Band* 1967 album. This is an archetypical work in terms of Blake's particular collage style. The artist himself explains: "I like the idea that my works might please young people who listen to pop music." And this work did indeed reach the hands of millions of people.

The Love Wall features several characteristic elements of Pop Art. On a wooden, etched panel the artist applies various images: a reproduction of a work by Millais, numerous postcards and magazine clippings. One part of the work's surface has been covered by images from the life of a couple as well as by pictures of popular actors; the viewer will recognise here the face of Marilyn Monroe. The work's lower part features a series of diagonal bands: this is a fragment from a work by Westerman, the American artist whom Blake greatly admired. Furthermore, a mirror has been placed almost at the centre of the composition, reflecting the viewer's image and thus making him/her part of the work, forming a new relationship between the work and the viewer. The work forces the viewer's eye to hastily, almost stressfully, move from one image to the next in search of something familiar with which one might perhaps identify.

Blake's intention is to create a showcase in which love may be exhibited. And his plan proves successful. This particular composition is a typical example of a work of Pop Art, manifesting at the same time the major impact that familiar, photographic images have on each one of us. On the other hand, however, the five patterns integrated into the work's wider unified context, prove that Blake draws his inspiration from the natural world, which he realistically depicts, thus demonstrating his designing skills: accuracy, simplicity and clarity of line, as well as an excellent organisation of the painting's space, which, together with narrative elements, trigger the viewer's emotional response.

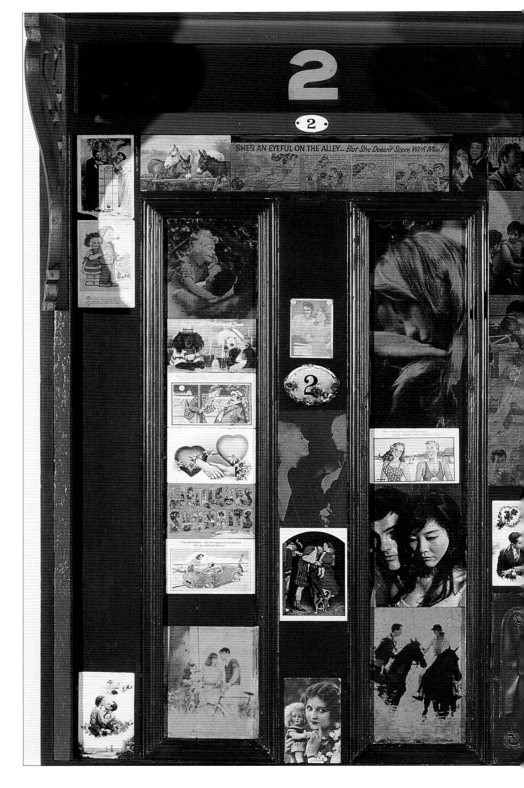

The Love Wall

1961
COLLAGE AND WOOD RELIEF CONSTRUCTION
125 X 237 X 23 cm
COLL. CAMJAP/CALOUSTE GULBENKIAN FOUNDATION, LISBON

Michael Bolus

Michael Bolus is a typical example of the group of artists that came to be known as the New Generation Group and who considered sculpture to be more a means of expressiveness and creativity rather than an established, formalist element of expression. Bolus, like Caro, abandoned the use of stone and began working with metals (iron and aluminium), which offered him endless possibilities for experimentation on what mainly interested him: that is, the form's own balance and potential for expansion across space. In general, he works on the basis of a model, creating sculptures on a human scale that do not rise above the viewer's eye level.

The relationship between the viewer and the work as examined by Bolus is particularly obvious in *Bowbend*, a sculpture that stands on the floor as if it were autonomous in space and creates the impression of a barrier. On a very finely carved surface, bands of yellow, green and red cover the aluminium's metal countenance and offer it a very soft, glossy texture. The work's surface becomes curved at its lower end, imparting to an otherwise strictly geometric composition a sense of instability and unpredictability. Bolus manages to develop form on the metal's surface in a uniform and balanced manner. The entire composition seems to have been completed at one stroke.

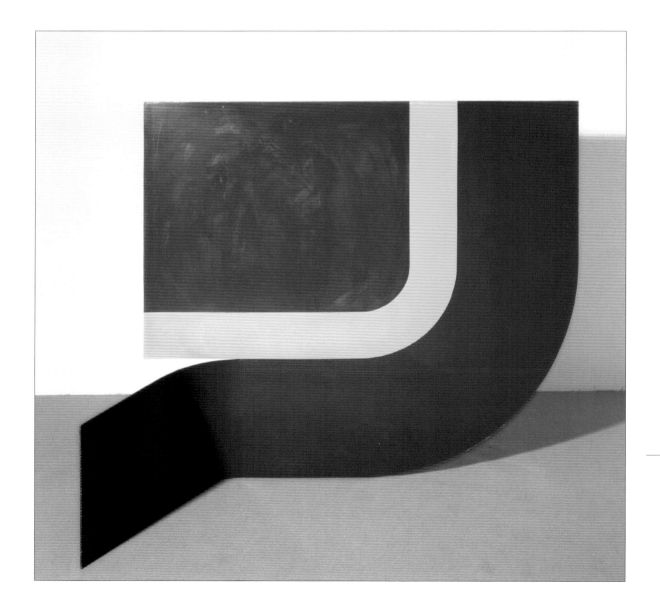

Bowbend

1964
PAINTED STEEL
122 X 137 X 65 cm
COLL. CAMJAP/
CALOUSTE GULBENKIAN FOUNDATION, LISBON

Derek Boshier

Derek Boshier was one of the first British artists to endorse Pop Art and one of the first to abandon it. Although his Pop period was short-lived, he is considered to be one of Pop Art's main representatives. Boshier, together with Phillips, Jones and Caulfield, formed the nucleus of British Pop. Of all the painters to have graduated from the Royal College, Boshier is the only one committed to decoding marketing strategies and commenting on contemporary politics, his work at times bordering on satire.

His early works, which contributed to formulating the language of Pop Art, were highly standardised, containing coarsely magnified images. Soon, however, he developed a narrative technique by which he could comment on situations such as the Americanisation of Europe and the development of SDI plans or on political crises such as the invasion of Cuba, as well as make allusions to advertising, pop-music and current affairs. Consumer products such as Pepsi-Cola do not appear in his work to praise contemporary pop-culture, but rather to provide evidence of a treacherous attack by international corporations and the American way of life.

While most artists in the context of British and American Pop Art adopted a provocatively ambiguous stance to their subject matter, Boshier was one of the few who were clear and categorical about their opinions and statements. He believed in collective social and political responsibility. In 1961, he began working on a short series of paintings with a view to criticising an advertising campaign for striped toothpaste. It was a critical outlook on the underhand, sly means used by the market and the advertising business to dupe and take advantage of consumers, reducing them at the same time to the status of mere numbers. Influenced by the work of authors such as Marshall McLuhan, John Kenneth Galbraith and Vance Packard, Boshier depicts modern man as being identical to his peers, as if all are wearing the same overalls, faceless and lacking a personality - mere pieces in a jigsaw puzzle.

His work *So Ad Men Became Depth Men* allows us in a particularly acerbic way to see the extent to which consumerism has distorted and devoured human existence. It is about the power of advertising to dominate and the loss of personal identity. Man is nothing more than a 'de-personified' item mixed with toothpaste, a typical consumer product.

In 1962 he travelled to India on a one-year scholarship and created a series of works, most of which were eventually destroyed. In terms of style, these works resembled those of the previous period, but their themes drew exclusively on Hindu symbolism and mythology. When he returned in 1963 he created hard-edge abstract paintings centring on geometric forms, abandoned obvious representation, but continued to hint, through form, at architectural structures and urban networks. Sometime around the mid-1960s, he explained: "My recent work

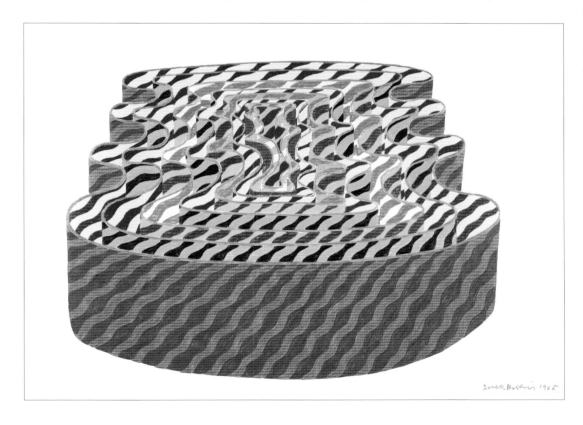

Untitled

1965
FELT PEN ON PAPER
73.4 X 103.8 cm
COLL. CAMJAP/CALOUSTE GULBENKIAN FOUNDATION, LISBON

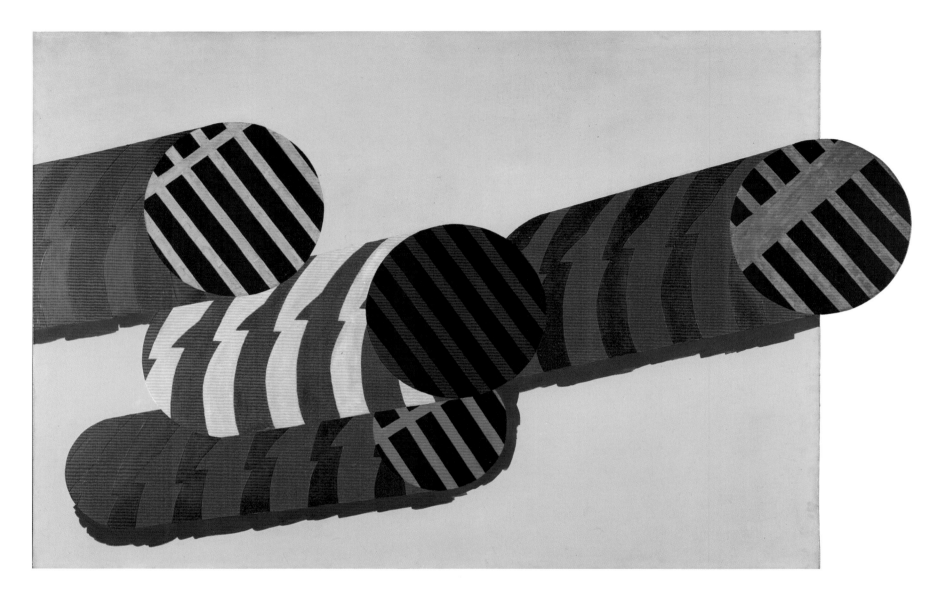

is a continuation of previous, rather more representational work, but the formal qualities have changed. All the images I have used in my new work have more to do with the notion of 'portrayal', of projection, rather than with the phrase 'Twentieth Century Fox presents' that we find at the beginning of films. All these images stem from social conditions or are mainly projected in advertising."

In *Untitled* and *Out* one can detect the fusion of colour and form, in the context of which, nevertheless, colour remains autonomous. At the same time, the symmetry of design emphasises the works' abstract character adding a particular feeling to them.

Out

1964
OIL ON SHAPED CANVAS
152 X 237 cm
COLL. CAMJAP/CALOUSTE GULBENKIAN FOUNDATION, LISBON

So Ad Men Became Depth Men

1962
OIL ON CANVAS
153 X 153 cm
COLL. CAMJAP/CALOUSTE GULBENKIAN FOUNDATION, LISBON

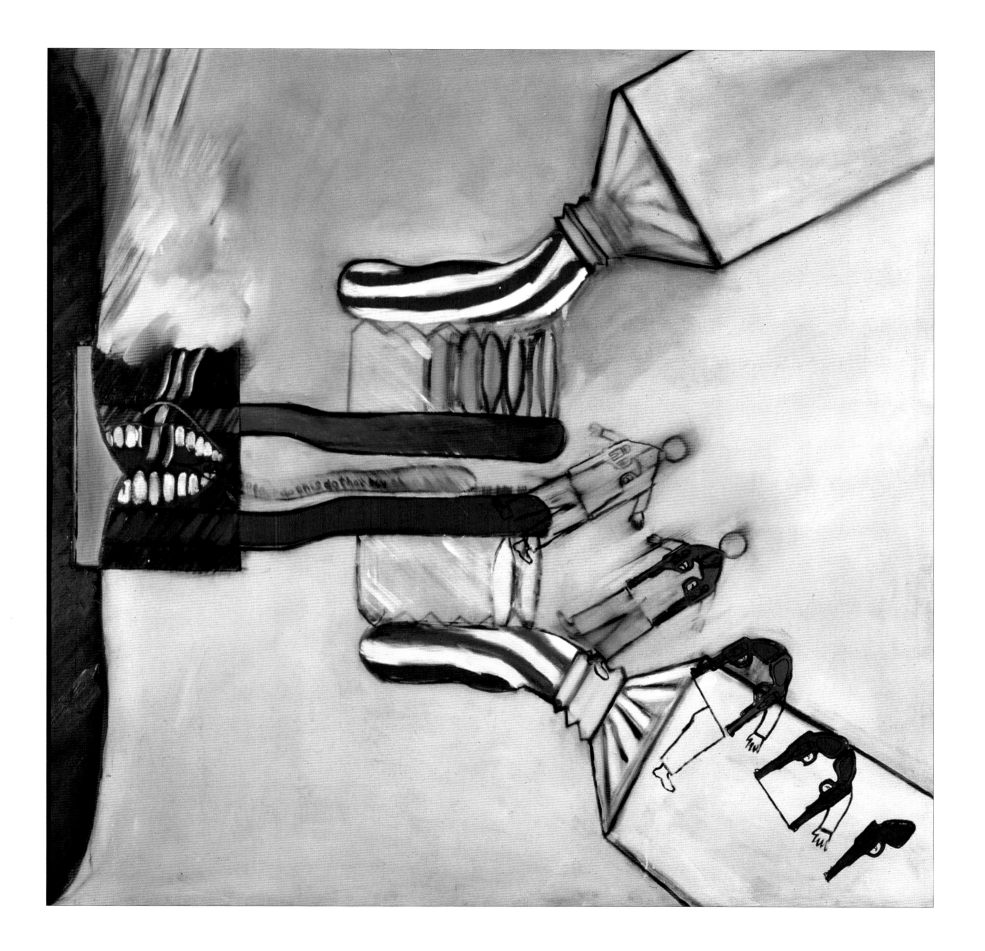

Anthony Caro

British sculptor Anthony Caro is considered to have made the most significant contribution to the shaping of contemporary sculpture, changing both its expressive language and discourse. At the beginning of the 1960s Caro formulated a personal dialectic which by means of revolutionary methods and endeavours aimed at questioning the kind of monumental, monolithic sculpture that the work of Moore, as well as that of Chadwick and Butler, had established in Britain over a period of forty years.

Caro's style was shaped very early on, already from the beginning of the 1950s, as a result of the various influences he received during his stay in the USA and of his acquaintance with artists such as David Smith, Kenneth Noland and Helen Frankenthaler. In the USA he also had the opportunity to meet artists of the New York school. His fertile, inventive mind espoused the kind of socio-political change that was under way in Europe and America and sought to find ways to convey it in his sculptural work.

Caro redefined sculpture and introduced a number of avant-garde issues regarding its concepts, methods and media that would thenceforth influence and define a sculptor's work. He thoroughly examined the communicative function of sculpture and abandoned the tradition of the sculptural model as well as the use of clay in order to offer a new dimension to experimental practices with regard to abstract sculpture. He was devoted to creating sculpture from everyday objects, from the most incredible things, from reality itself. So, when he returned to Britain he began experimenting with the use of metal as the basic material of his compositions, which took on the form of industrial constructions rather than that of uniform, monolithic sculpture.

Pink Stack is a synopsis of issues examined by Caro at the time. The work is made up of metal rods arranged towards different directions starting from the floor but not attached to any kind of base. In his works Caro did away with sculpture's traditional pedestal so as to transform it into objects that coexist with those in our everyday lives. *Pink Stack* becomes part of its surrounding space and immediately enters both the viewers' field of vision and their particular space. As is the case with most of the sculptures he created during that time, colour becomes the main element that unifies form.

From 1970 on, Caro actively continued to experiment with industrial materials, while at the same time introducing new elements such as bronze and objects of everyday use, imparting a Cubist character to his work, which simultaneously began to reveal a subtle shift towards elements that alluded to traditional representation. His revolutionary approach both to the practice and theory of sculpture defined the trends in sculpture that were developed by his students at St Martin's School of Art, the now established artists of a generation that we have come to know as the New Generation Group (David Annesley, Michael Bolus, Phillip King, Tim Scott, William Tucker, Isaac Witkin). Anthony Caro and his revolutionary ideas about artistic creation continue to influence contemporary generations of artists.

Pink Stack

1969
PAINTED STEEL
120 X 335.5 X 147.5 cm
BRITISH COUNCIL

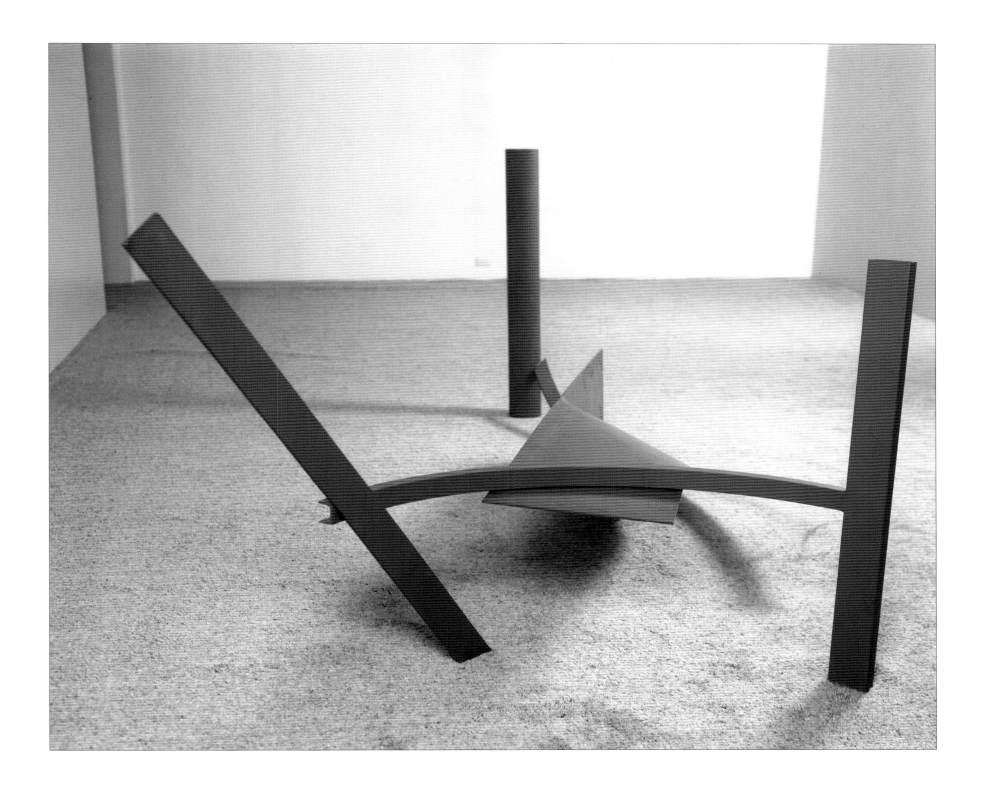

Patrick Caulfield

Caulfield, alongside Derek Boshier, Antony Donaldson, David Hockney, Allen Jones, R. B. Kitaj and Peter Phillips, belongs to a group of artists that emerged at a particular time, whose work testified to a host of influences particularly from the realm of popular culture. These artists supported one another and shared the same enthusiasm for discovering the raw material of their work among the products of mass culture (from food packaging to images of star system personalities such as Marilyn Monroe and Brigitte Bardot). They all participated in the 1961 *Young Contemporaries* exhibition. ICA (Institute of Contemporary Art) curator Lawrence Alloway described them as artists that associated their art with the city. The appeal of popular art is present here, but at the same time checked by means of riddles and paradoxes that have to do with the play of features that characterise the different levels of meaning incorporated in their work. This combines real objects, a presentation that keeps to the same scale, a fragmentary character in terms of semiotics, and narrative and the practice of engraving.

Caulfield's work cannot easily be classified: his paintings seem one-dimensional and stylised and he does not seem to be interested in depicting emotion; in a way, some of his works possess a cartoon-like quality. Caulfield re-examines familiar images, their source often being the history of art itself - as is the case with Delacroix's *La Grèce expirant sur les ruines de Missolonghi* - as well as the omnipresent vase of flowers. In doing so he limits his attention to their most essential elements, using few, smoothly finished bright colours. Despite the fact that his work is generally considered to fall into the category of third-generation British Pop, Caulfield wished to distance himself from the kind of pop iconography found in the work of some of his peers and find his own voice. He insistently refused the title of pop artist, claiming that he consciously avoided images that referred to contemporary culture and dealt instead with established subject matters such as landscapes, interior spaces and still lifes. In this way he remained in contact with the European tradition through a renewal of traditional subject matters, stressing the fact that his inspiration derived from Europe and not from the USA. He has based specific characteristics of his work and ideas concerning their arrangement on the work of the Cubists and modern artists such as Juan Gris, Georges Braque, Fernand Léger and Henri Matisse; work that develops the decorative trend in art.

From the beginning of his career as an artist, Caulfield has focussed on painting and engraving and created works that are easily recognisable thanks to the use of pure, vivid colours, which serve to animate and highlight form. By applying paint on plywood, he creates an ordinary, common surface for his ready-made images, thus emphasising the irony in his particular method of representation. He aims at creating works that are emblematic and decorative at the same time, opposing in this way the perception of painting as an act of transcribing a kind of atmospheric realism.

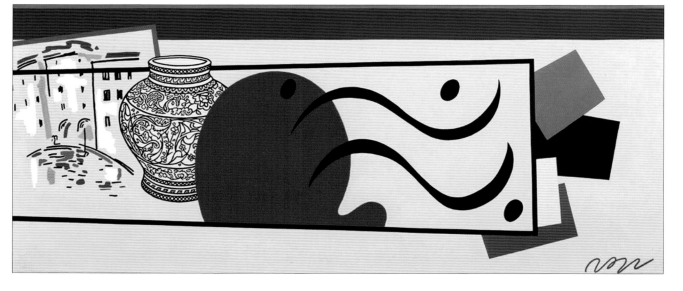

In *View of the Bay*, Caulfield picks a panoramic view of a small bay complete with boats and houses. The painting's arrangement centres on the diagonal line created by a string of minute flags. Blue is the dominant colour, illuminated by yellow, orange and white strokes, which the artist uses for the boats, their reflection in the water, the roofs and windows of houses. The wind's presence is suggested in an almost photographic way.

In his large-scale work entitled the *Artist's Studio*, heterogeneous elements have been arranged together. Thus, a seaside town has been depicted by means of the basic lines and contours of a lushly decorated vase; an image that recalls a palette of undulating lines and dots. Coloured shapes possess a self-sufficiency similar to that of abstract forms and have each been assigned a specific function, as if they were part of an imaginary game. This work also allows us to see how Caulfield renders the object of art impersonal by choosing to express himself in a way that is rather 'flat'.

Artist's Studio

1964
OIL ON BOARD
91.4 X 281.4 cm
ARTS COUNCIL COLLECTION, HAYWARD GALLERY, SOUTH BANK CENTRE, LONDON

View of the Bay

1964
OIL ON BOARD
122 X 183 cm
COLL. CAMJAP/CALOUSTE GULBENKIAN FOUNDATION, LISBON

53

Bernard Cohen

In 1960 and 1961 Bernard Cohen participated in the exhibitions of the Situation Group. His creative activity reached its peak between 1958 and 1963, when the structures of thought that he believed would change the world emerged. He considered the identity of Pop Art to have crystallised in 1963 forming a movement that explored the practices of the media on the one hand and, on the other, distinguishing artists into those who wished to develop some kind of visual intelligence and those who wanted art to be more commercial. He was obviously influenced by Pollock's Abstract Expressionism and held the work of Fontana, Dubuffet, Miró and Dalí in high regard. His early works combined anti-Formalism and Surrealism and reflected his intention to create images imprinted with the effort that is entailed in the creative process, similar to Pollock's celebrated paintings created by means of the dripping technique. Thus, images acquired the character of events and of successive moments in time. His works tell of a very particular idiosyncrasy and combine a number of different styles. However, the element that distinguishes and highlights his art is that of complex, interwoven lines gradually rendered in vertiginous superabundance. He begins developing this in 1962 in drawings such as *Drawing Imperial I* and *Drawing Imperial II* - in which the viewer can still follow the maze-like course of lines - to ultimately arrive, in 1963, at the labyrinth of *Mist*.

Cohen shapes his compositions carefully along the traces of a line that follows the hand's command; it is the hand that selects either free or restrained movements. This manner of expression enables the discovery of intense emotions and highlights the dual role of the act of painting: graphic processing and presentation on the one hand and natural experience on the other. Taking this direction we might observe that in *Mist*, which is one of his most characteristic works, the viewer may discern and follow the artist's play with one single line. All possibilities of plasticity offered by this simple pictorial element, which may even acquire a three-dimensional quality, unravel before the viewer's eyes. From the faintest of pinks to the brightest of yellows, from the subtlest of traces to a vigorous presence, from strict linearity to the sensual curve, from an agitated spire to a harmonious undulation, this infamous line hardly leaves any areas unoccupied.

In the mid-1970s Cohen traded his earlier preferences for vast expanses of flat colour, impulsively applied on the painting's surface, for a more accurate technique, containing dense layers of designs, colours and 'stretched' forms. He thus found a way to link his personal concerns with a painting that depicts social habits, producing an art that contains both formalist elements and his own symbolic allusions.

Drawing Imperial I

1962
PASTEL ON PAPER
52.5 X 63.5 cm
COLL. CAMJAP/
CALOUSTE GULBENKIAN FOUNDATION, LISBON

Drawing Imperial II

1962
PENCIL AND COLOURED
CRAYON ON PAPER
52.5 X 63.5 cm
CALOUSTE GULBENKIAN FOUNDATION, LISBON

Mist

1963
OIL AND TEMPERA ON CANVAS
152.5 X 152.5 cm
COLL. CAMJAP/CALOUSTE GULBENKIAN FOUNDATION, LISBON

Barrie Cook

Barrie Cook holds a special place in British art since his name has been linked with the use of the spray painting technique for a period of almost forty years. Cook's achievement helped establish the use of spray painting in the realm of the visual arts, as it was eventually considered to be a suitable, genuine and flexible expressive medium. Cook's works, which were massive in scale, requiring the use of public spaces for the purpose of their presentation and often appearing to extend beyond the viewer's field of vision, had a profound influence on many younger generation artists. He seems interested in creating works of a holistic character, whose physical presence possesses a markedly tactile quality, while at the same time constituting an exceptional, transcendent vehicle for meditation. This is why they incorporate strictly abstract geometric structures and develop exceptionally powerful and subtle combinations of colour. Simultaneously, these works reveal a play of optical effects achieved by means of their patterns' blown-up forms, thus creating an illusion of the three-dimensional and leading the viewer to feel that they must be vibrating.

Continuum presents a cluster of cold, dark and at the same time well-defined, almost vertical rows, interwoven in a most unlikely manner with a brighter, luminous background, generating a claustrophobic feeling in the viewer that is at one and the same time contradicted by the feeling that the painting seems to be emitting its own internal light. It is also worth noting that *Continuum* is marked by a rational organisation of its various elements and by a sense of balance between the various principles relating to linear and chromatic structure.
As the viewer attempts to trace the work's specific identity, both his sight and imagination are triggered to follow the course that form takes through colour and the light that seems to be emanating from the background. Colour acquires shape and moves in a specific direction; it spreads and radiates, asserting its presence in space while at the same time organising it.
The artist's personal style in conjunction with the interminable dialogue between form and colour create work that stirs the unconscious and provides a genuine visual experience.

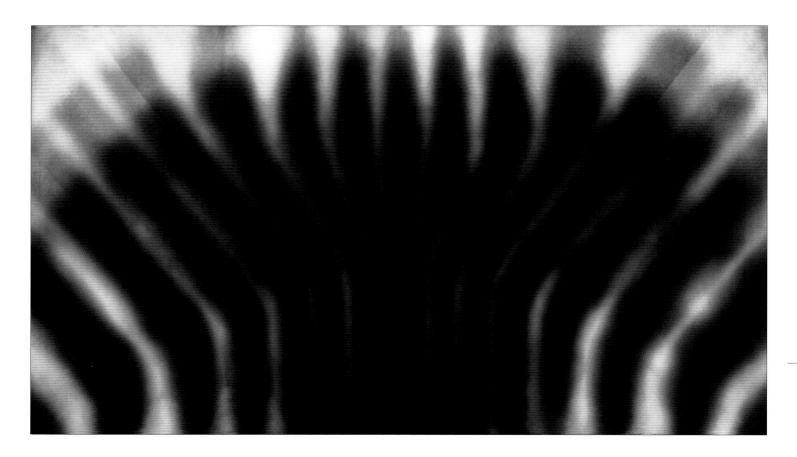

Continuum

1971
SPRAY PAINT ON PAPER
78 X 138 cm
COLL. CAMJAP/CALOUSTE
GULBENKIAN FOUNDATION,
LISBON

Robyn Denny

In *The Art of Robyn Denny* (Black Dog 2002), David Allan Mellor writes: "For eight years, between 1961 and 1969, Robyn Denny painted what are arguably some of the most accomplished abstract paintings made in Britain, in the twentieth century. They are grave and gracious - sometimes capricious - objects which, among other things, invite the spectator into an extraordinary space of projected bodily presence." Denny's large-scale abstract canvases deal with notions of time and space. The artist genuinely aspires to raise the viewer's awareness, to trigger a process by which each one of us arrives at his/her own, subjective definition of the real and the imaginary. Denny's work is characterised by a continuous investigation into the boundaries between the dimensions of time and space. He is concerned with the 'sense' of things around us and the way this may alter on the basis of perception and memory.

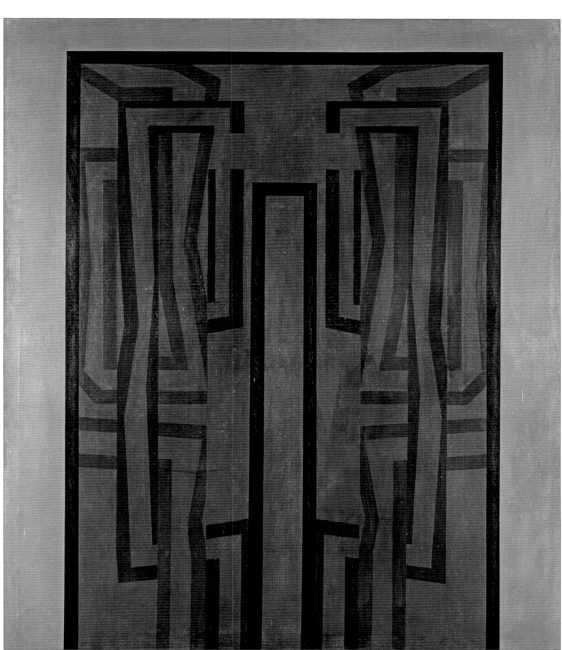

In *Jones' Law 1964*, the viewer is called upon to interpret the image by means of the dominant optical data already present in the canvas, but also to allow his imagination to trace elements that are not obvious, but are, instead, revealed to each person in a subjective manner. The symmetrical, geometric form dominating the canvas gives the impression of a three-dimensional object, like a door leading to some space in the realm of fantasy. The viewer is left to decipher the complex meaning of this form and to provide a subjective interpretation of this particularly mysterious optical stimulus.

Throughout most of his work Denny, like many of his contemporaries, skilfully and ingeniously processes the age's complex system of urban space as well as the relationship between artwork and viewer. He thus creates symbolic images that allude to real space and enter the viewer's perception in the form of mirrors reflecting his own, personal environment.

Jones' Law 1964

1964
OIL ON CANVAS
214 x 183.5 cm
COLL. CAMJAP/CALOUSTE GULBENKIAN FOUNDATION,
LISBON

Antony Donaldson

Antony Donaldson's contribution to the development of Pop Art in Britain was significant. Already in 1964 he formulated the particular vocabulary of his painting and chose the expressive means by which he would convey the age's atmosphere of optimism and tranquillity. Donaldson combines form and content in a very specific, tongue-in-cheek style and the graphic-design-like, almost impersonal manner in which he manipulates the canvas' smooth surface, as well as his use of repetition, bring him closer to the 'clean pop' of American artists and their tendency to record popular entertainment and mass production in aesthetic terms. The era's positive climate was transferred to the work by means of a central theme: the female figure.

Young, beautiful, joyful, particularly sexy women flood the surface of his large tableaux and tell of the age's spirit of euphoria, its demand for an improved standard of living as opposed to the hardships experienced during World War II. According to Michael Compton one may discern in some of Donaldson's early works the impact on the artist of De Kooning's *Woman* series; only Donaldson seems to be contemplating the female figure in a way that rather resembles that of an adolescent; one that is more attractive and more charming.

In *Summershot* the artist attempts to simplify the image of the beautiful model in terms of shape. The impressive female figure in the nonchalant, carefree posture is repeatedly presented, thus indirectly suggesting its source, which appears to be a photographic print. Facial features are barely outlined for the purpose of evoking the appropriate hint: this is not a portrait of a specific person, but rather an imaginary figure that dominates a male mind.

The decorative background, whose outline alludes to the image of a target, a camera lens or even that of a pair of binoculars, as well as the colour's intense horizontal surfaces, serve to underscore the voyeuristic feeling that imbues the image.

Formalist qualities in *Summershot* refer to the work of Andy Warhol. Here, too, there is an attempt at the visual repetition of imagery that has already been oversaturated by the era's magazines and advertisements. Additionally, in the same way as David Hockney, one of his contemporaries, Donaldson analyses the idealised lifestyles of Southern California and the Hollywood film industry in a manner that is both highly optimistic and ironic.

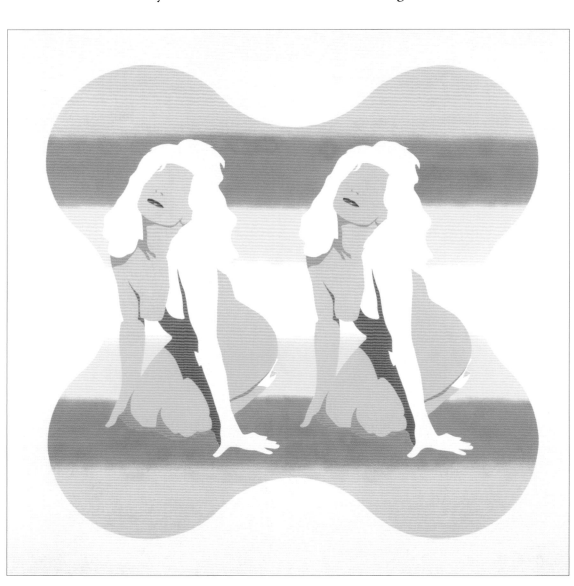

Summershot

1964-1965
ACRYLIC ON CANVAS
172 X 172 cm
COLL. CAMJAP/CALOUSTE GULBENKIAN FOUNDATION, LISBON

Garth Evans

The main characteristic of Garth Evans' work is the presence of elements that point to a tendency towards dispersal and expansion. His work, however, also proposes a set of communication codes through a language that is ambiguous and open-ended, by means of which the work itself suggests the way in which it is to be viewed and evaluated. Through its formalist approach and lack of specific content, Evans' work ultimately acquires a pronounced, ingeniously humorous character. Evans aims to point to the following paradox: every object that has been created is a projection of things felt by the person who created it.

His work titled *White* - a relief in fibreglass painted an icy white, which seems to challenge the laws of physics and gravity - gives the impression of being substantially lighter than it should in fact be. This is an abstract, semi-geometric and sculpturally organic form that seems to be following the logic of design more than that of construction. Although Evans adopts in his work an approach based on the logic of construction, he does however mainly combine it with influences emanating from the work of American abstract artists.

White

1965
PAINTED FIBREGLASS
123 X 140 X 9 cm
COLL. CAMJAP/
CALOUSTE GULBENKIAN FOUNDATION,
LISBON

Richard Hamilton

Richard Hamilton is considered to be one of the fathers of Pop Art, the other two being Peter Blake and Eduardo Paolozzi (Hamilton was in fact the first to use the term "pop" in a letter he addressed to architects Alison and Peter Smithson).

There is no clear dividing line between Hamilton's artistic oeuvre and his multifarious activities. His work in art and education and the radiance of his personality left an indelible mark on the art community of the 1950s and 1960s, determining the practices of subsequent generations of artists up to this day.

Throughout his work, Hamilton used the codes and symbols that emerged in the world of advertising and the media, in the realm of popular music and of the high-profile social events taking place in Western societies, in order to criticise precisely what he was depicting: the world of consumerism. His work can be seen as a semiotic analysis of the symbolism inherent in advertising and as a critique of the effect of such symbolism on the moral principles, desires, values and stereotypes that govern contemporary life. Hamilton has been a designer, professor, critic and curator. He was a member of the Independent Group, an avant-garde artists' group, and he was also one of the organisers of *This Is Tomorrow*, a historic exhibition held in 1956 at the Whitechapel Art Gallery, for which he created the poster from his hybrid collage titled *Just What Is It that Makes Today's Homes so Different, so Appealing?*, a characteristic work of the Pop Art movement.

With remarkable spontaneity the artist explored new media and technologies such as photography, screen printing, collage, and photo-mechanic methods of production in order to satirise the contemporary industry of the spectacle and the mythology of advertising. From 1964 onwards the ready-made became his primary means of expression; however, he would continue to combine ground-breaking processes of production with traditional media like painting and lithography. His work often includes references to the tradition of painting.

People

1968
PHOTOGRAPH, SCREENPRINT, LETRATONE AND COLLAGE ON PAPER
65 X 84 cm
COLL. CAMJAP/CALOUSTE GULBENKIAN FOUNDATION, LISBON

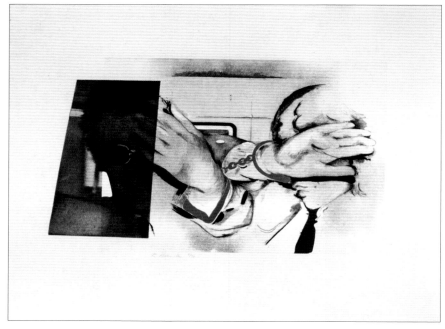

Swingeing London 67 - Etching

1968
ETCHING, AQUATINT, EMBOSSING AND COLLAGE ON PAPER
56.5 X 72.7 cm
COLL. CAMJAP/CALOUSTE GULBENKIAN FOUNDATION, LISBON

Chicago Project I (1969) is the result of an invitation extended to Hamilton by the Museum of Contemporary Art in Chicago to participate in the *Art by Telephone* exhibition. A series of instructions was given by Hamilton via the telephone to the young American artist Ed Paschke, who then proceeded to complete the process by painting the image. Instructions included purchasing a postcard, which was then processed, photographed anew, enlarged and painted over. In *Chicago Project II*, a work of the same year, Hamilton himself created a different version of the above-mentioned work, using the image that Paschke had selected and following a similar process.

Hamilton's training was at first traditional, as he began by attending courses at the Royal Academy Schools. He acquired experience in the area of commercial art while working at the Design Unit Group and at EMI-Electrical & Musical Industries, London, and was introduced to contemporary discourse and the avant-garde during his studies at St Martin's School of Art and the Slade School of Fine Art.

Equipped with this multifaceted, interdisciplinary educational background, he established the foundations for his subsequent investigations into art, which were to focus on the use of different media with a view to eliminating the boundaries between 'high' and 'low' art. His goal was to consistently study and explore the relationships formed between different manners of expression, different styles and preferences which were theoretically considered to be mutually exclusive.
First and foremost, his work is a reflection of his personality, unravelling it in all its various aspects, while at the same time it is also a reflection of the intellectual and social concerns of his time and of its characteristic imagery. Armed with faith and dexterity, Hamilton 'harnesses' the present and along with it a torrent of change which he attempts to sublimate and transform into art.

Traditional and established genres of painting, such as landscape painting, the nude, the depiction of domestic scenes, portraiture, and so on, are renewed through use of the imagery of contemporary life and of the new technologies of the twentieth century.
At the same time, Hamilton was interested in images of a random, spontaneous character, which possesed the power of the unsophisticated, the familiar, the everyday. This is evident in works

The Critic Laughs

1968
LAMINATED PHOTO-OFFSET
LITHOGRAPH
WITH SCREENPRINT,
ENAMEL PAINT
AND COLLAGE
ON PAPER
59.3 X 46.5 cm
BRITISH COUNCIL

such as *People* and *Bathers (a)*, where the image's power lies in a scene that is familiar in the context of everyday contemporary life (a gathering of people on a beach) that has then been processed and depicted by means of the era's newest technologies. The same applies in the case of his work entitled *Swingeing London 67* in which the spirit of an entire era is conveyed with striking immediacy by means of a newspaper photograph showing gallery owner Robert Fraser and rock star Mick Jagger as they are being arrested for possession of illegal drugs. Here, Hamilton employs collage and offset, which is mainly used in the production of widely circulated publications.

Two other works of his depict a completely different visual reality, thus stressing Hamilton's diverse technical skills and the pluralism of his artistic vision. In *The Critic Laughs* he criticises the practice of art criticism and the art critic's profession through use of different media such as offset lithography, collage and enamel paint. Part of an electric toothbrush and an artificial set of teeth become the vehicle for caustic satire and the medium through which a kind of dual symbolism is expressed: the image is a symbolic rendering of the work's title, while the title itself provides support for the image. Located at the opposite end of Hamilton's creative practice, however, *A Portrait of the Artist by Francis Bacon* is an example of how he deals with his educational

Richard Hamilton

background in the history and tradition of painting, while at the same time paying tribute to Francis Bacon. What the viewer encounters here is a portrait that bears all those technical and formalistic characteristics that function to produce the quality of distortion so typical of Bacon's works.

Hamilton ingeniously borrows elements from the tradition of painting and the culture of his homeland and incorporates them into his ground-breaking practice, inviting the viewer to freely interpret his work's emotional and intellectual content.

Chicago Project I

1969
ACRYLIC ON PHOTOGRAPH ON BOARD
81.3 X 122 cm
BRITISH COUNCIL

Chicago Project II

1969
OIL ON PHOTOGRAPH ON BOARD
81.3 X 122 cm
BRITISH COUNCIL

Bathers (a)

1967
SCREENPRINT
70.5 X 94.5 cm
BRITISH COUNCIL

A Portrait of the Artist by Francis Bacon

1970-1971
COLLOTYPE AND SCREENPRINT
82 X 69.2 cm
BRITISH COUNCIL

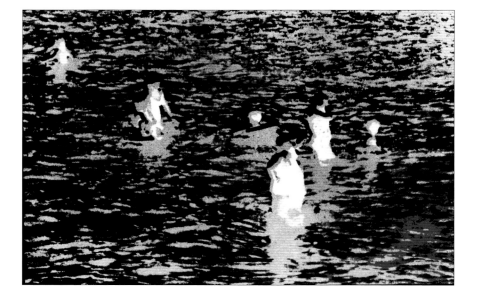

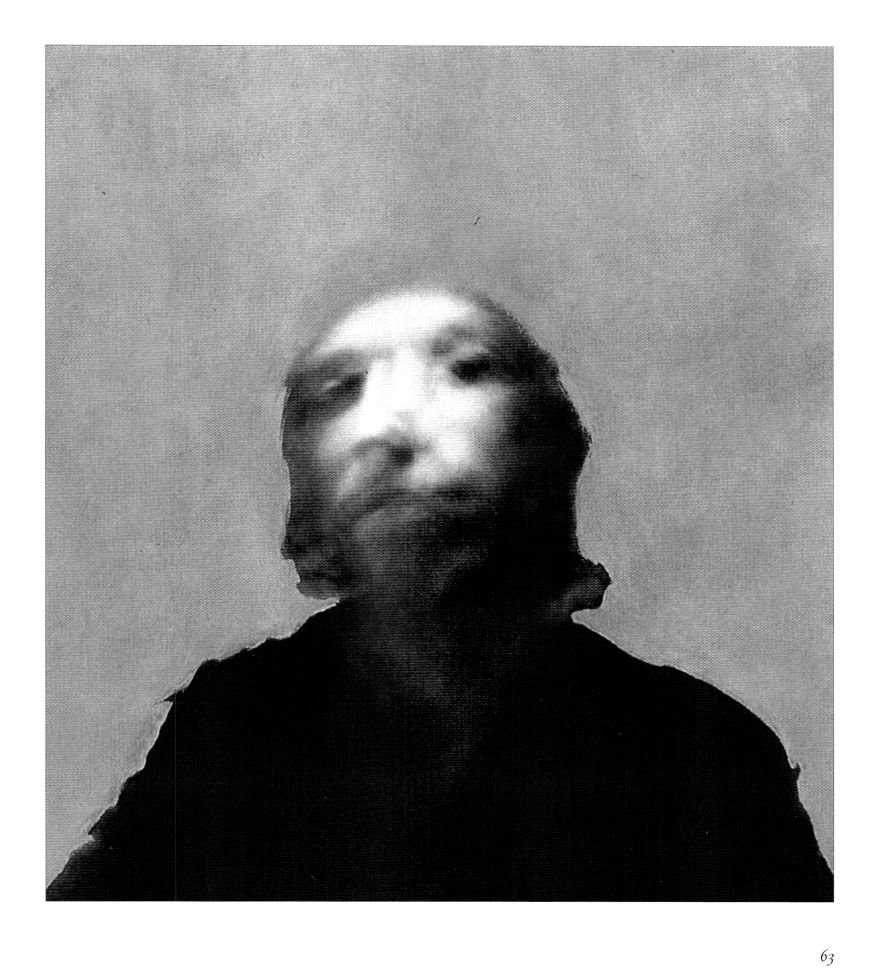

David Hockney

At the end of the 1950s and the beginning of the 1960s the Royal College of Art functioned as a hothouse for young artists and a laboratory for experiments that would result in a new visual language through free cohabitation of contradictory modes of expression, a notable shared characteristic in the work of these young artists. This is where David Hockney received his education, alongside R. B. Kitaj, Peter Phillips, Derek Boshier, Richard Smith and Allen Jones, who would all be associated with the emergence of British Pop Art. At the beginning of the 1960s, Hockney maintained a somewhat fringe relationship with Pop Art, anxiously trying to disassociate his name from the term; however, his teasing sense of humour and playful and irreverent style in fact manifested the continued existence of pop elements in the core of his work.

His strong personality, his sense of humour and remarkable drawing skills, coupled with a subject matter that drew on personal experience as well as on a literary background, allowed him to assimilate and transcend the various influences he received and to create a distinct artistic identity from a very young age. He enjoyed recognition almost from the beginning of his career and is considered to be one of the most multi-talented and popular British artists.

His creativity is boundless, a fact attested by the diversity of his work and activities (he is a painter, engraver, photographer and stage-designer). His style can take on many different modes; it can be flat, illusory or natural. Encouraged by R. B. Kitaj, he was to introduce personal issues into his art, while at the same time remaining faithful to his new area of interest: modernism. Daily reality is the source of his subject matter: still lifes depicting a simple T-shirt thrown over the back of a chair, landscapes inspired by his journeys to the USA, Europe and the East, scenes from his life in California – an almost hedonistic environment of swimming pools, palm trees, a life free of all restraints and a sun that always shines –, but also images that reflect his homosexual preferences. Furthermore, his work includes a large number of portraits of his friends and acquaintances and of his parents; Hockney is a great portrait artist and the human presence is one of the key themes in his work.

In *Renaissance Head*, which harks back to Piero della Francesca's *Portrait of Federico da Montefeltro, Duke of Urbino*, the harmony of composition is immediately recognisable, as the male head portrayed in profile is placed under the opening of an architectural arch, while a landscape can be seen in the distance. This is a painting that recreates Renaissance iconography and invites the viewer in a slightly naughty and somewhat ironic manner to take part in a game. Despite the rather anachronistic source of the work and the fact that it artificially preserves a system of past references, Hockney employs a contemporary style in a manner that transforms the image into a brilliant example of Pop Art ethos.

The artist himself explains: "At that time I could quite well draw figures in an academic style, but that was not what I wanted to do in

Figure in Helmet and Cloak

1963
INK ON PAPER
50.5 X 31.8 cm
COLL. CAMJAP/
CALOUSTE GULBENKIAN FOUNDATION,
LISBON

**Pigs Escaping
from a Hot Dog Machine**

1961
INK ON PAPER
45.5 X 60.5 cm
COLL. CAMJAP/
CALOUSTE GULBENKIAN FOUNDATION,
LISBON

painting and so I had to return to something that was […] an opposite style, a crude style, because I enjoyed its likeness to children's art, which in turn resembles Egyptian art, where everything is the same. So I felt that in using this style, I was in fact using an anonymous style, and this was every time the case with these works."

These words seem to take shape, to acquire form and colour in works such as *Pigs Escaping from a Hot Dog Machine* (1961), *Figure in Helmet and Cloak* (1963) and *Man in a Museum (or you're in the wrong movie)* (1962). In these works, the unconventional and the impulsive combine with crudely rendered figures that recall a child's drawing; an unpolished, graffiti-like style complements the rough texture of colours. These works owe much to Jean Dubuffet's *faux-naïf* idiom as well as to the example set by Picasso, whose 1960 retrospective at the Tate Gallery had a decisive impact on Hockney's free style.

Although the bulky figure depicted in *Man in a Museum (or you're in the wrong movie)* - reminiscent of totemic figures - constitutes an impressive presence as it is drawn in a manner that makes it appear sturdy and almost rigid, as if drawn by the hand of a child, the viewer's attention is however attracted by the delicate human figure standing on the left and reflecting Hockney's exemplary drawing skills. This also provides an element of sharp stylistic contrast, as if the work itself had been created by the hand of two different people.

The fact that Hockney consciously chooses to grant his expression an anonymous style is the very reason why we might connect him to Pop Art, despite the fact that he, himself, denounces such a connection. He so often produces images related to personal or other experiences in a style that seems so commonplace, that he eventually generates the feeling that the language he uses is a language common to all.

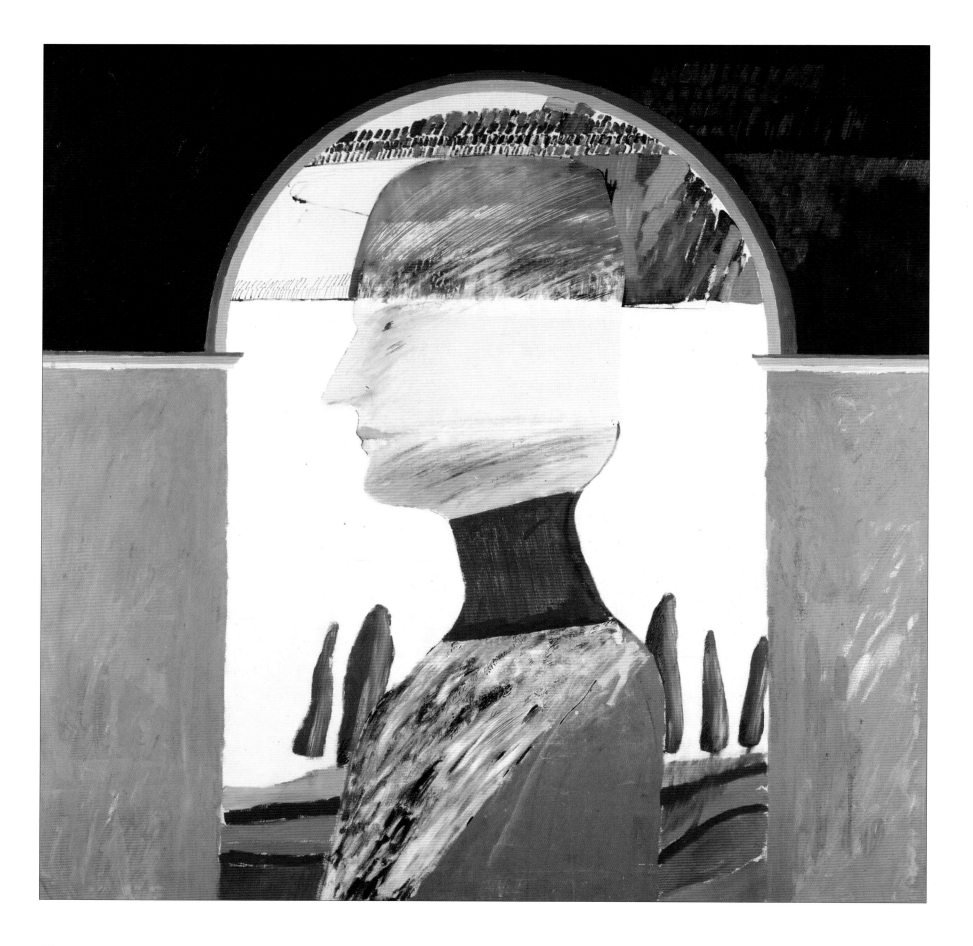

Renaissance Head

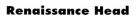

1963
OIL ON CANVAS
122 X 122 cm
COLL. CAMJAP/CALOUSTE
GULBENKIAN FOUNDATION,
LISBON

Man in a Museum (or you're in the wrong movie)

1962
OIL ON CANVAS
147.3 X 152.4 cm
BRITISH COUNCIL

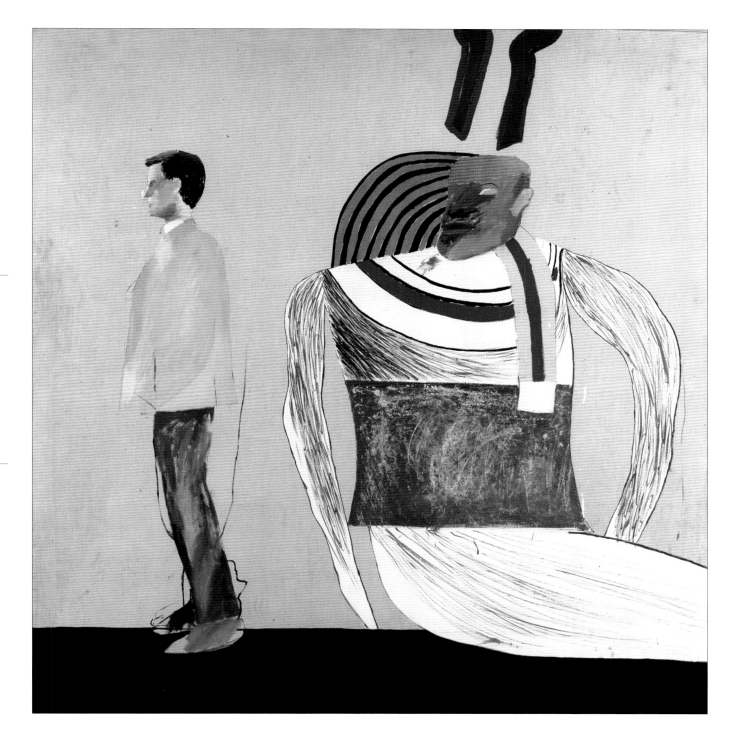

Howard Hodgkin

Hodgkin emerged as an artist in the 1960s with work that appeared to be directly related to Abstract Expressionism. Audiences usually associate his work with the movement of Pop Art,[1] unjustly so however, since the absence of a pop iconography in it is more than obvious. On the basis of his artistic background, the artist developed a personal manner of expression. To a great extent, his obsessive concerns as to the discourse of art reflect the emphasis he places on personal relations, which, according to him, are the fundamental issue not only as far as the meaning of art is concerned, but also that of life.

At first glance, the particular style of his painting appears to be abstract, whereas in fact his works always centre on a predominant theme. Very often he deals with the area lying between abstraction and representation. As he himself notes, the memory of an encounter usually serves as the point of departure for every one of his works. In the same way that the subject's realism often lies in the negation of its conventional depiction, so it is that on the surface of a given convention's impersonal character Hodgkin traces the potential for expressing very specific impressions. In his view it is only the most simple of elements that might make this convention more effective. Hodgkin's vocabulary is made up of the disc, the stripe, the drop and the noose; simple forms that his work animates and renews. During the decades of the 1950s and 1960s and in the early years of the 1970s his work was based on a depiction of people in indoor spaces and was permeated by a sense of anticipation, a hovering expectation of something that might or might not happen. The space itself usually contained works of art and the persons depicted were friends of the artist; often artists themselves or collectors. The power of colour in combination with the painting's carefully devised arrangement communicates emotion to the viewer. His works are not easy to 'read' at first glance, although their titles do offer some hints as to their theme. For example, they often announce that the painting is a portrait of an individual or couple, despite their ostensibly abstract character.

Hodgkin's paintings are often the embodiment of the artist's words: "Specific people, each relating to one another and to me". This intention to depict his favourite subject - people in indoor spaces - can also be seen in the work entitled *Mr and Mrs Patrick Caulfield*. The painting's foreground is taken up by the room's floor, which is divided in two areas, a larger green one and a smaller one in red. In the right-hand section of the painting the couple is represented by means of coloured, curved, abstract forms marked by an acute immediacy and expressive power. The painting's arrangement is highlighted through territories of vibrant colour, by straight lines forming angles and blending with circles and semicircles. Balance in the composition is simultaneously upset and achieved anew by the introduction of the vertical white tape with orange fringes.

Summarised rendering of the painting's subject, abstraction and clarity of colour allow the viewer to partake of, and at the same time detach himself from, the reciprocal relation between the painting's message and its aesthetic savouring. The viewer understands that these are moments that have been imprinted on the artist's memory and that are laden with tension, both visual and spiritual; moments that have acquired a particular form through human relationships, through feelings and things and that now manifest themselves outside the continuum of time. It is a set of different forms every part of which claims and attains autonomy, perfection and harmony, while the viewer is trying to interpret the image as if dealing with some kind of riddle.

[1] At the beginning of the 1960s he painted concentric circles, using colours that mostly recall packs of detergent.

Mr and Mrs Patrick Caulfield

1967-1970
OIL ON CANVAS
107 X 127 cm
COLL. CAMJAP/CALOUSTE GULBENKIAN FOUNDATION, LISBON

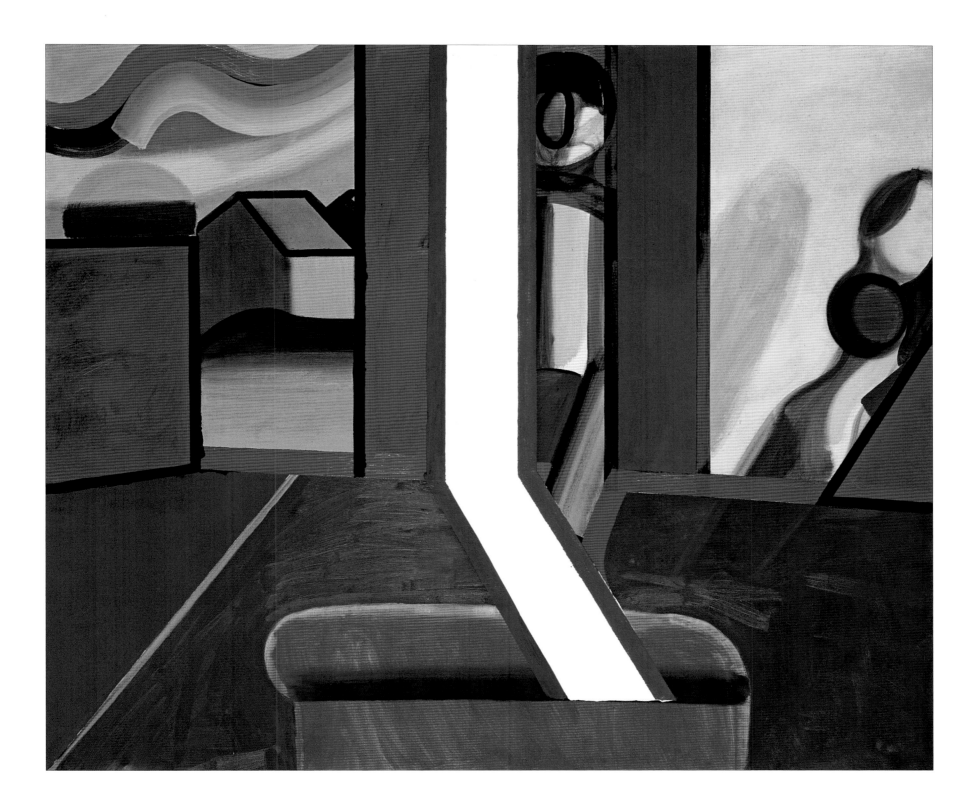

John Hoyland

Hoyland's paintings give the impression of fields in which 'something appears to be happening'; autonomous environments marked by the strong presence of the element of mobility. During the 1960s, Hoyland's entire work suggested a gradual shift from linear and symmetrical abstraction towards the creation of compositions in which vivid fields of colour were placed more freely on the canvas' surface, thus producing impressive, bright images of colour. Like other artists of the Situation Group (Robyn Denny, Bernard Cohen, Paul Huxley), Hoyland also advocates the kind of painting that provides intense optical stimuli. He wishes for spaces and motion to be considered as autonomous elements and not to be associated with reality. Colour and form become the very subject and content of his paintings.

In early geometric works, such as *No. 19, 26.12.1961*, Hoyland thoroughly examines the relationship between image and background by means of colour. The influence of Colour Field Painting and of post-painting abstraction, trends that developed in the USA in the post-war period, is evident here.
Soon, geometric abstraction is replaced by compositions whose predominant feature is the interaction of different colours and the visual manifestation of a colour's own gravitational force.

In *8.8.63* the image develops and assumes form thanks to colour. Like Huxley, Hoyland too manages to create the sense of perspective as well as that of motion through solid, seemingly impenetrable surfaces of colour.

Hoyland meticulously explores the dynamics of expression and autonomy inherent in colour which he used not only in the paintings he created, but also in the lithographs, silkscreen prints, engravings and monotypes that he produced during that period. From 1970 on his brushstrokes become increasingly gestural and expressive in the majority of his works, and the density of colour thus achieved grants these works a three-dimensional character. The painting itself becomes a visual happening, which the senses are called upon to perceive and relish.

No. 19, 26.12.1961

1961
OIL ON CANVAS
244 X 213.5 cm
COLL. CAMJAP/CALOUSTE GULBENKIAN FOUNDATION, LISBON

8.8.63

1963
OIL ON CANVAS
173 X 173 cm
COLL. CAMJAP/CALOUSTE GULBENKIAN FOUNDATION, LISBON

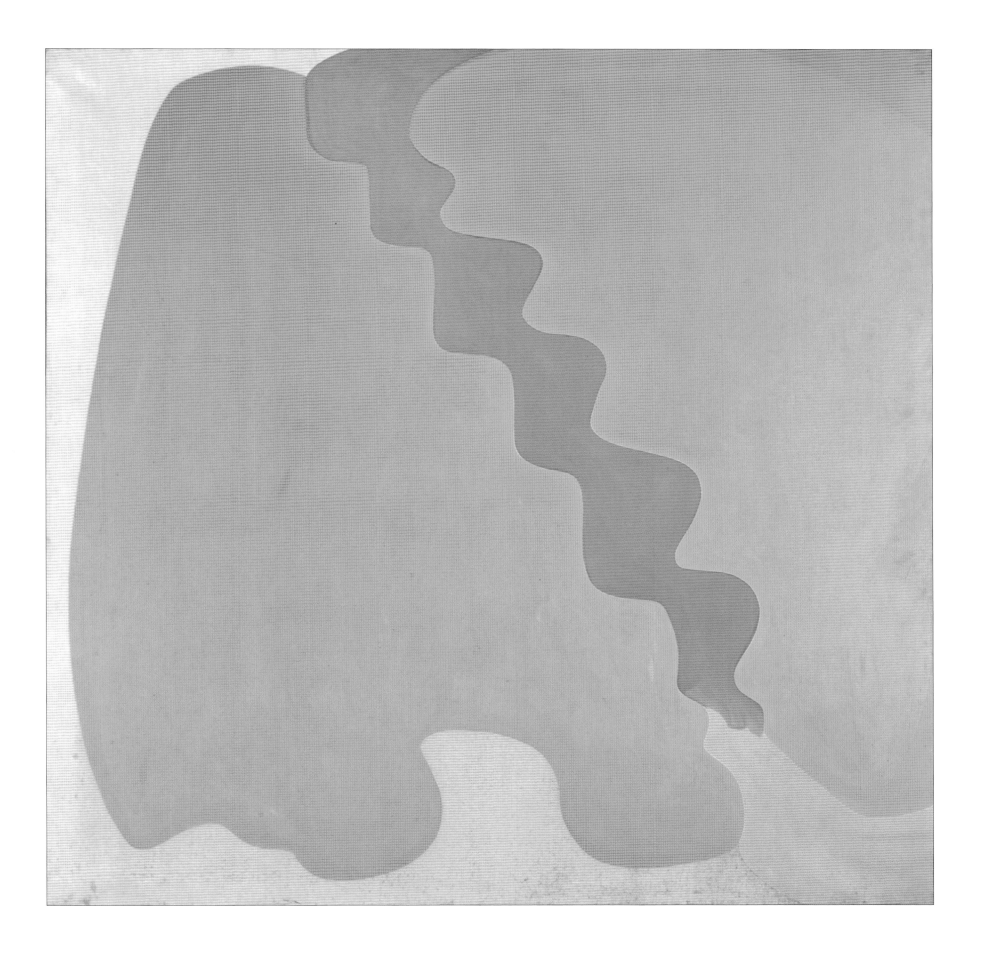

Paul Huxley

Paul Huxley belongs to the generation of artists that was profoundly influenced during the 1950s by the predominant trend of New York Abstract Expressionism: a trend that had a decisive impact on developments in the painting practice of London artists, as also seen in exhibitions of the Situation Group at London's ICA. More than ever before, painting seemed to be acquiring an autonomous character and Huxley was one of the first to respond to this challenge.

The chief characteristic of Huxley's work lies in the limitations the artist himself places on the painting's arrangement as a whole. *Untitled No. 36* offers a clear view of the artist's main concerns, which seem to persist and recur throughout much of his work. In order to examine the issue of representation and the dynamics of abstraction, Huxley invokes a wide range of different volumes, structures and colours; he studies and defines the behaviour of these autonomous elements on the painting's surface. The square-like support structure, as well the contrast between the single-coloured background and the oval-shaped forms that support the painting's diagonal arrangement are typical of his work. The starting point for the painting's dynamic development is the square shape in the top left-hand corner which will then transform into a more abstract, almost immaterial sign in the work's lower part. Drastic changes in form seem to be caused by the canvas' own downward inclination and force of gravity.

Untitled No. 36, July-November 1964

1964
OIL ON CANVAS
173 X 173 cm
COLL. CAMJAP/
CALOUSTE GULBENKIAN FOUNDATION,
LISBON

Allen Jones

Allen Jones studied at the Royal College of Art (1959-1960) alongside his contemporaries Peter Phillips, David Hockney, Derek Boshier and Patrick Caulfield. A painter, sculptor, designer, engraver and stage-designer, Jones is in fact associated with the emergence and development of Pop Art in Britain. Despite the fact that he derives his themes from contemporary reality and that his work is characterised over-all by a blending of different techniques and styles, the artist seems less influenced by the semiotics of the everyday and more concerned with emphasising the abstract composition of colour as this was developed by the Modernists, more specifically Wassily Kandinsky and Robert Delaunay. In the wider range of his work the human figure is predominant. His compositions are a combi-nation of representation and abstraction and attest to the philosophical and didactic approach adopted by the artist for the purpose of striking a balance between emotions and the intellect.

An emphasis on sexuality, an element that recurs in both his paintings and sculptures, indeed encapsulates the spirit of the 1960s, a time when sexual emancipation and moral freedom attained its ultimate expression through the arts.

For Jones, the act of creation occurs through fusion and by extent identification of the male and female elements. In *"Dance with the Head and the Legs..."* features that allude to a male figure seem to be embracing, to be coming together and becoming one with an abstract female body. This contemporary couple surrenders to a fusion whose pace is frenetic and the viewer is called upon to decode the surfaces of colour, the fragmentary image of human parts, the abstract lines and contours, so that he may arrive at his own scenario.

Jones' interest in the world of the senses and the balance between the male and female genders is rooted in his study of the theories of Nietzsche, Jung and Freud, as well as in his familiarisation with the commercial, sexually-charged imagery prevalent in New York City during his stay there between 1964 and 1965.

In *Parachutist No. 2*, the representational element is assimilated by the abstract one. Geometric shapes enclose mysterious, surrealist colours and forms, emotion being their point of departure, and transform into an explosive composition that renders in visual artistic terms the spirit of the age, the frantic pace of urban reality.

Parachutist No. 2

1963
OIL ON CANVAS
209.5 x 124.5 cm
COLL. CAMJAP/
CALOUSTE GULBENKIAN
FOUNDATION, LISBON

The artist's famous glass sculptures of 1969 that portray the romantic, sexual encounter of a man and a woman are an excellent symbol of the period of grace and freedom in swinging London's revelling environment. The works' subject and bold representational character were castigated by the feminist movement that had begun to emerge at the beginning of the 1970s. Since then the artist adopted a more formal approach to the human figure, which stressed the element of abstraction, nevertheless retaining the sensual dimensions of colour and of the human body itself.

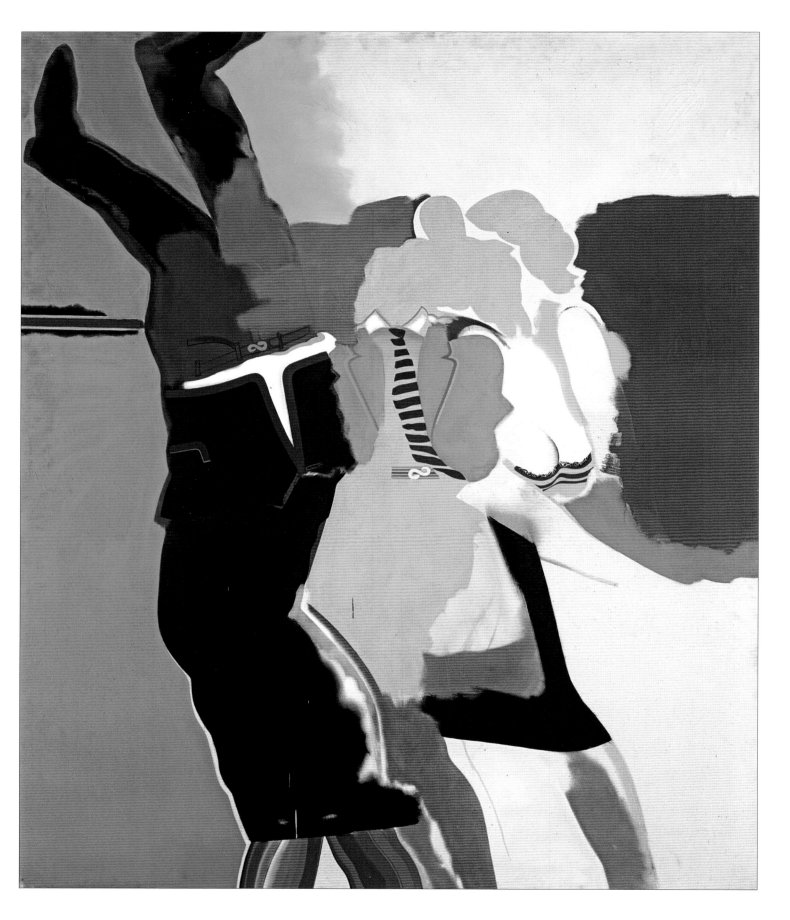

**"Dance with the Head
and the Legs..."**

1963
OIL ON CANVAS
183 X 152 cm
COLL. CAMJAP/
CALOUSTE GULBENKIAN
FOUNDATION, LISBON

Michael Kidner

Michael Kidner's paintings thoroughly explore the phenomenological relationship between artwork and viewer, as well as the way in which the combination of design and colour creates the illusion of movement.

Kidner was profoundly influenced by the abstract landscape artists of the St Ives School of Art in England. An avant-garde artist of Op Art himself, he introduced in his work a series of standardised patterns and abstract symbols with a view to creating complex systems of meaning, which the viewer is called upon to interpret.

The notion of the superiority of pure colour over form gradually began to preoccupy him, as he believed that "the most brilliant of images is created by the post-image produced on the eye's surface".

So it is that in an extensive series of works colour becomes the predominant representational idiom and appears to take on the role of the painting's content.

Kidner's abstract paintings contain articulated visual meanings (which constitute, in the artist's view, a kind of challenge similar to that posed by the emergence of perspective during the years of the Renaissance), in arrangements governed by a sense of harmony that recalls the generic harmony of nature.

Brown, Blue and Violet No. 2 is a clear example of trends proposed by the artist at that time. The repetition of specific elements and the use of two colours that closely relates to form create an intense result, particularly charged with visual stimuli. Kidner explored the complete range of possibilities offered by Op Art's visual language, both in his paintings and his sculptures.

Brown, Blue and Violet No. 2

1964
ACRYLIC ON CANVAS
124.5 X 152.5 cm
COLL. CAMJAP/
CALOUSTE GULBENKIAN FOUNDATION, LISBON

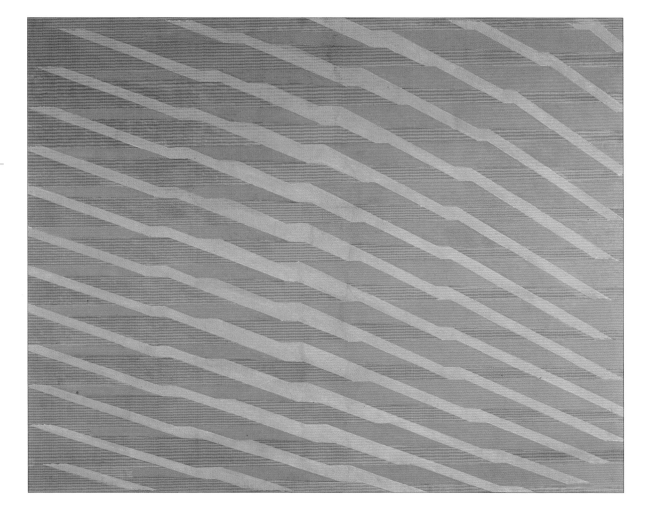

Phillip King

In 1965, the Whitechapel Art Gallery organised an exhibition called *New Generation*, which featured the work of talented young artists representing the new generation of British sculpture. This was an exhibition in which viewers were faced with unprecedented works; harmonious abstract forms, brightly coloured works in one piece placed directly on the floor without the mediating element of a base, made of plastic, metal and fibreglass and produced in human scale; a radically new and different concept of sculpture.

Six among the nine participating artists, namely David Annesley, Michael Bolus, Phillip King, Tim Scott, William Tucker and Isaac Witkin were associated with St Martin's School of Art and were all students of Anthony Caro.

Encouraged by trends promoted at St Martin's School of Art, among other things, King rejected those elements that had defined the style of sculpture up to that point and turned towards the challenges posed and limitations placed by new materials.

From the early to the mid-1960s he created works that bring to mind objects of everyday use. During the same period he showed an interest in materials such as clay, plaster and plastic. King was one of the first artists to use plastic and was well informed about the sculptural potential and limitations of new materials. What he was mostly interested in was the way in which a plastic surface might reflect light and diffuse it in space. He was attracted by simple and clear forms: the geometric shape that mostly drew his attention was the cone, a form that has no particular history in the tradition of sculpture. He repeatedly used the cone in order to experiment with its outline, its volume and surface, with the way it relates to space, as well as with the different tones of bright colour that this form each time seems to take. Towards the end of the decade, King proved receptive to the challenges posed by the theory of Minimalism and attempted to blunt his work without however undermining its solid formalist foundations. He reaffirmed the modern perception of sculpture as an immutable, solid, uniform, autonomous and distinctive body constituted on the basis of intuition. Towards the early 1970s he began to show a preference for complex and multifaceted sculptural arrangements.

In *Ripple* we encounter a static geometric quality coupled with the energy and power of the abstract form that challenges the viewer's visual perception. The elements that compose the work are defined at the same time by the sense of harmony that permeates their form and the sense of contrast in their motion, thus subverting the dominant understanding of sculpture as a practice producing monolithic, solid objects. This work is a reflection of motion, order, rhythm and colour, elements which in this case eliminate the sculpture's weight.

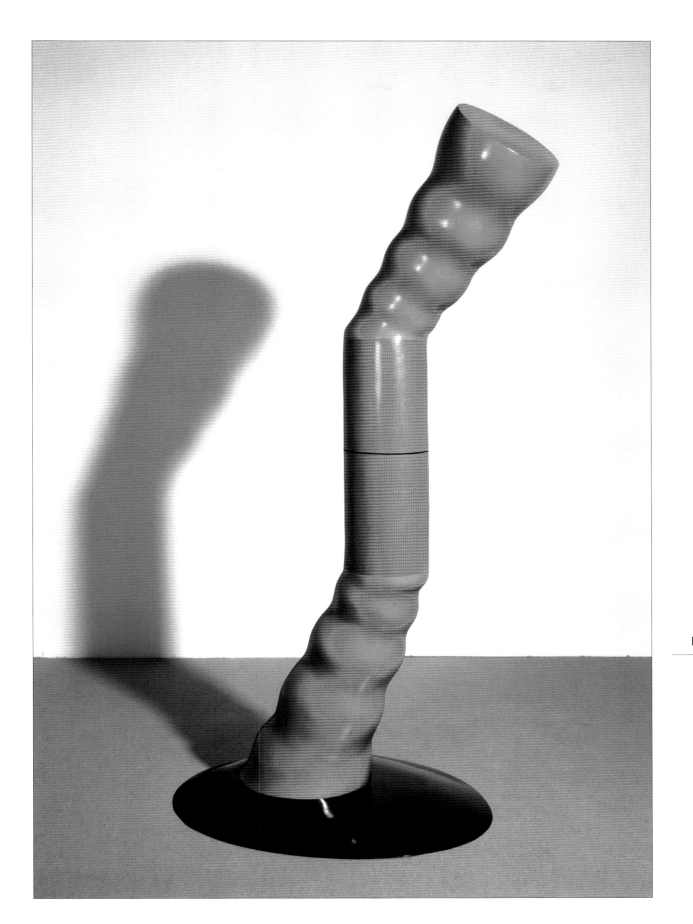

Ripple

1963
PLASTIC
188 × 89 × 77 cm
COLL. CAMJAP/
CALOUSTE GULBENKIAN FOUNDATION,
LISBON

77

Jeremy Moon

Moon is an artist of abstraction, known for his use of colour and for the almost inert, jaded style of his works. He creates large bright abstract works characterised by a particular sense of simplicity and ingenuity. He uses flat uniform arrangements, intense clear colours, and regular rhythmical geometric forms and designs. His work suggests a special acuity and at the same time reveals a lively, playfulness that gives it an unexpectedly contemporary countenance. Moon wishes to create art that is founded on a purely visual approach; he wishes the viewer to see only the uniform end result of his painting, avoiding any kind of one-sided references to form and design. He does not intend to create representational or illusory paintings, a fact that makes viewers feel that his work does not offer any experience. But although his paintings give the impression of flat and static compositions that do not stir the senses, we may still perceive in them a call for a more intimate, inwardly directed kind of investigation. Moon is of course interested in the impact his works have on the viewer and attempts to highlight them by means of the titles he chooses.

The canvas in *Concord* is made up of five different parts that have been arranged together. A set of black oval dots moving upwards and set against a uniform yellow background creates a dynamic feeling.

In *Drawing 71/77* squares are defined and highlighted by means of the ingenious use of colour and we might see that despite the image's seemingly static quality, the combination of form and colour creates an impression of subtle movement; an almost constant flow.

The source of aesthetic pleasure in these two works is to be traced mainly in the simplicity of form and the austerity of design, both virtues that possess large resources of energy and vigour and are easily communicated to the viewer.

Drawing 71/77

1971
PASTEL ON PAPER
20.3 X 25.3 cm
BRITISH COUNCIL

Concord

1964
ACRYLIC ON CANVAS
112 X 387 cm
COLL. CAMJAP/
CALOUSTE GULBENKIAN
FOUNDATION, LISBON

Eduardo Paolozzi

Innocence and sophistication, impulsiveness and discipline, myth and device, purity of form and ambiguity of meaning: this is Paolozzi's spirit, always to be found somewhere in between two opposite extremes, manifesting itself in constructions of totemic symbolism, in bronze automatons and structures of joined mechanical materials. His work possesses elements that allude to trends in Surrealism.

Objects that interest him might include a damaged lock, a toy frog, a rubber dragon, a toy camera, spare parts of a clock or radio, a broken comb, the sight of an old RAF bomb, parts of an old gramophone or car, as well as the skin or bark of products of nature. Joined into one, integrated whole, all these objects lose part of their individuality and adopt the residual quality of a fossil. Fragments coming from a world overwhelmed by the machine hint at the eternal, the imperishable, and thus it is that these forms, in their final make up, also include 'manifestations' of the archetypal.

Paolozzi is concerned about heightening perception, isolating and highlighting instances of visual experience that have formerly been underestimated. By transforming the ready-made,[1] by placing refuse material in the environment of art, he suggests ways in which we might perceive a different or new aspect of things.

His sculptures before 1961 were made up of joined refuse material in bronze. In the following years he worked with polished aluminium and painted steel and created monumental works marked by a utopian reconciliation of technology and early twentieth-century avant-garde. The artist himself explains: "... I had been travelling from London to a machine production facility in Ipswich for ten years in order to create sculptures using industrial methods. References to tradition cast in metal, traces of other machines and architectural pieces."

By cutting various images and rearranging them within new combinations, Paolozzi is able to explore the limits of their identity, renewing their meaning at the same time through novel arrangements and designs. In his view: "... the entire sum of human experience is a vast collage". He believes that collage enables materialisation of a dual concept, namely that flesh may be altered by the object, while at the same time the object itself may transform into flesh.

These features of his art may be traced in his work titled *Mask*, where images of technology acquire the form of a human mask. Above all, Paolozzi is interested in investigating the artist's potential for transforming an ordinary, mundane thing into something

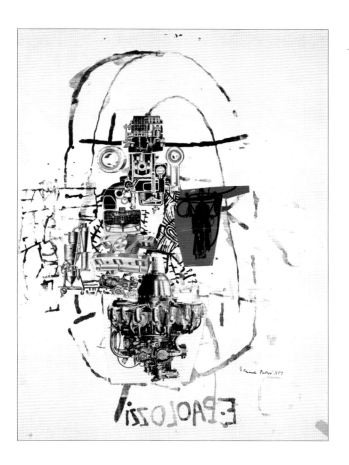

Mask

1957
SCREENPRINT
AND COLLAGE ON PAPER
68.5 X 50 cm
BRITISH COUNCIL

extraordinary, which is neither absurd nor setting a moral standard, but is instead a manifestation in itself of the miracle of everyday life. He notes that preceding works of art, technical journals and books are in large part a point of reference and source of subject matter for his work, reflecting a world of complex issues as well as a clear, well-defined language. For Paolozzi the logical order of the technical world can be as exciting as the magical objects used by the shamans in the Congo.

In *Diana as an Engine I*, the image of a religious idol, a totem, seems to have been created by elements that allude to industrial products. It is a figure that relates at the same time to objects of primitive ritual, to mechanised man and to science fiction movies. This is confirmed by the artist himself: "In reality, what I attempted to do with my sculptures was to transform the *objet trouvé* which I extensively use and which in the end is not immediately recognisable, since it has been

Eduardo Paolozzi

integrated more into a dream world of my own than into an ambiguous world of common visual illusion… Such found objects have survived in my sculpture only as ghosts of form."

Past the mutation of material and form, past the complexity of design and arrangement, the viewer's eye may rest, falling on the gentle, curved forms that recall the female figure, redolent of femininity. Thus, in *Dollus I* harmony and balance are reflected in the semicircles and rounded shapes. The simplicity of the work's lines is offset by the material's gaudy, vivid quality.

Dynamism and ingenuity are abundant in Paolozzi's sculptures. In general, the artist's work tells of his desire to treat our culture as if it were art; an alternative proposal to this trend in aesthetics that isolates the visual arts from life itself, as well as from other forms of art.

[1] The term is directly associated with Marcel Duchamp. Its application, however, is often limited to the act of appropriating a product of consumerist society, a standardised object that acquires the status of a work of art simply because the artist has chosen it to do so. It is a gesture rooted in the historical tradition of Dadaism; a result of the desire to destroy the myth of the artist as God. Although it constitutes an act of questioning and re-evaluating the meaning and object of art, it does not nevertheless serve as an anti-art statement.

Dollus I

1967
CHROME PLATED STEEL
128.9 X 78 X 15.9 cm
BRITISH COUNCIL

Diana as an Engine I

1963-1966
PAINTED ALUMINIUM
193.7 X 97.5 X 53.3 cm
BRITISH COUNCIL

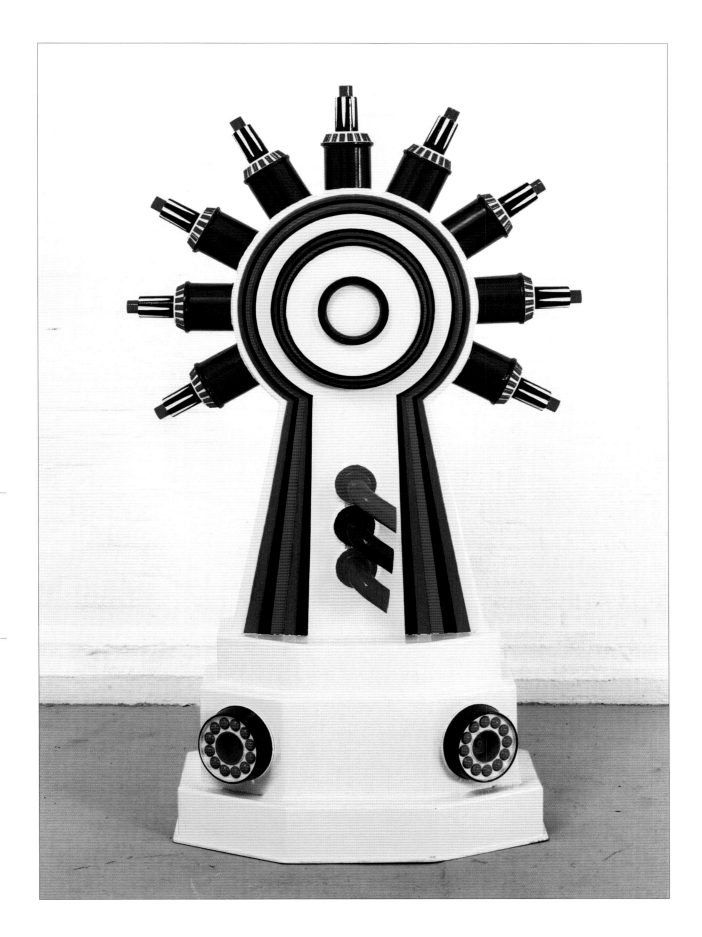

Peter Phillips

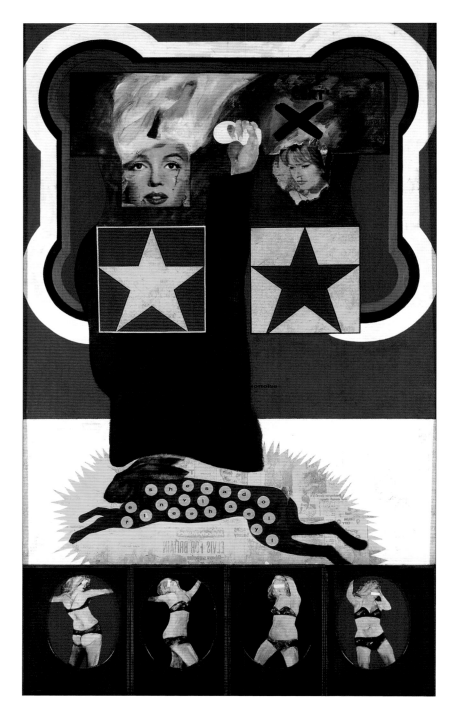

Contrary to many of his contemporaries, Peter Phillips never questioned the identity of Pop Art, but instead attempted in a large portion of his work to summarise his era through the images projected by the mass media. For many years he collected visual material from scientific and technical journals, advertising brochures, comic books and board games, which he then used to create hybrid paintings marked by the coexistence of heterogeneous elements charged with symbolism.

Phillips' academic training in technical design and his personal familiarity with graphic design resulted in the artist's departing from the standard, manual way of painting towards an investigation of techniques which would give his works the impersonal and anonymous character of advertisements, thus conveying the era's climate of consumer euphoria. Through the technique of collage, found images are processed and assume a place in the chaotic, futuristic environment of his monumental tableaux, which capture the 'aesthetics of the machine'.

In his work entitled *For Men Only ‒ Starring MM and BB*, symbols of contemporary life meet cultural emblems in a tableau that has the form of an advertising poster. Phillips incorporates strikingly contradictory and heterogeneous elements in the same context: set within a frame that refers to the religious paintings of the early Renaissance are pictures of female sex symbols ‒ Marilyn Monroe and Brigitte Bardot. The image of the rabbit is in part a copy from a game in the Victorian period, while the words "She's a doll" are formed within his body, followed by the name of a stripper who is represented underneath. Every element of the painting's semiotics seems to enhance its ironic nature, so that it may appear as a charming criticism of the world of mass consumption and of the icons this invents.

In a later work, *INsuperSET*, the viewer is invited to enter a 'super' phantasmagorical environment made up of fragmentary representational and abstract elements that are placed in geometrically delineated contours. Human figures surround a mechanical engine and lines of colour shaped like rainbows blend with the word "SUPER" and with the simplified symbols of starfish. Phillips inventively borrows visual devices and ways of presentation from the world of advertising, so that any attempt at decoding and interpreting the painting's content seems impossible. The random arrangement of elements and their dynamic flow lends the composition a sense

of mystery, but also an air of optimism with regard to contemporary life and the progress of mankind.

From 1964 onwards, Phillips abandoned the manual process of creating works and turned to mechanical means, such as the airbrush, with which he created works of extremely large dimensions, thus investing the end result with an almost photographic, industrial quality.

**For Men Only -
Starring MM and BB**

1961
OIL, WOOD AND COLLAGE ON CANVAS
259.6 X 153.1 cm
COLL. CAMJAP/
CALOUSTE GULBENKIAN FOUNDATION,
LISBON

INsuperSET

1963
OIL AND HARDBOARD INLAYS ON CANVAS
217.5 X 157 cm
COLL. CAMJAP/
CALOUSTE GULBENKIAN FOUNDATION,
LISBON

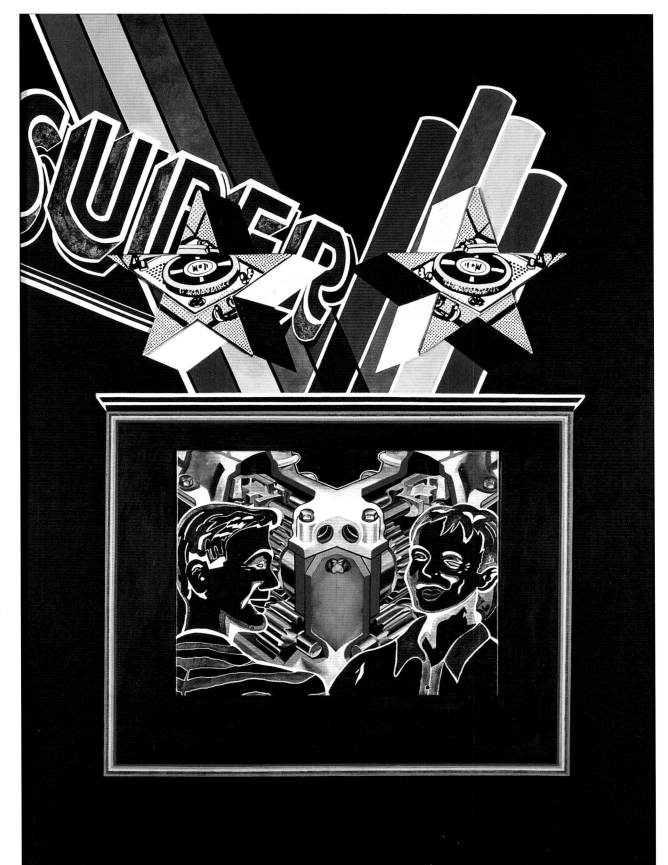

John Plumb

John Plumb received international acclaim as a result of the wide appeal his abstract paintings had in Britain in the 1960s. He was one of the first artists to redefine the principles of abstraction in painting as set out by American Abstract Expressionists. He participated in the significant *Situation* exhibition (Royal Society of British Artists, 1960), where he formulated, together with his fellow young artists participating in the exhibition, a new discourse about 'what painting is' and how one identifies its formalist limitations.

In *Needles* ∕ a work typical of the period in terms of its investigation of abstraction ∕ thin layers of colour aggressively invade the monochrome background, creating a complex, highly challenging environment. In this, the image's content is defined by means of colour, which seems to diffuse and break up into smaller particles of matter generating the feeling of frenzy that appears to be the result of the increasing mechanisation of contemporary life. The method of free, intuitive gesture is evident in this work.

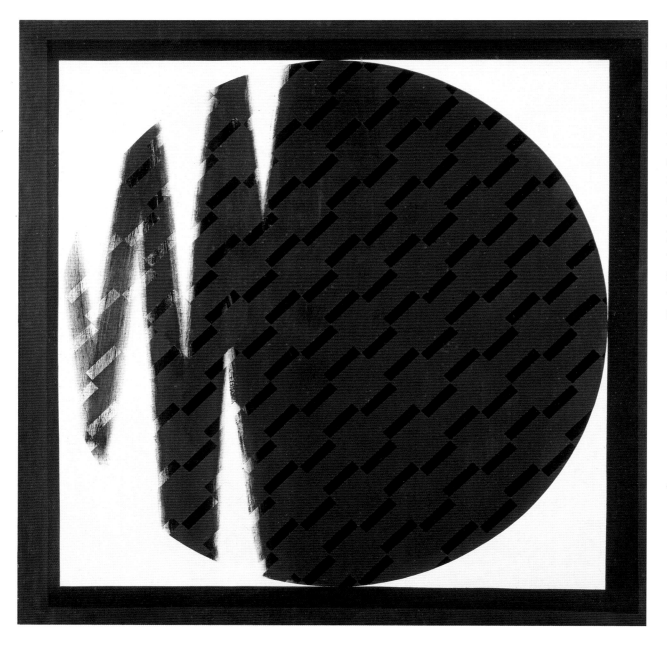

The content of Plumb's paintings is defined by colour, which underscores the notion of randomness and reflects an issue regarding the work's limitations, so that it ultimately becomes the painting's content itself. In the mid∕1970s, Plumb made a sudden, fundamental shift towards realistic representation. The majority of his new works dealt with how the water's surface reflects light. Soon, however, this new direction would give way to yet another novel approach to the elements and codes of abstraction, which Plumb then continued to process even more freely.

Needles

1963
OIL ON CANVAS
152.5 X 152.5 cm
COLL. CAMJAP∕
CALOUSTE GULBENKIAN FOUNDATION,
LISBON

Bridget Riley

Bridget Riley is a unique figure in the story of art: an artist who has consistently followed the same path in her art over a period of thirty-five years. She is considered to be an independent, highly individual voice in the context of British art since no other artist of her generation has followed a specific programme of work with such unwavering faith and commitment. She believes in the artist's social role and the social significance of art, as well as in the relationship between past forms of art and its contemporary manifestations. She articulates her views in a clear manner, in a language that avoids incomprehensible artifice and sophisms.

At the beginning of the 1960s and under the influence of Anton Ehrenzweig's and Victor Vasarely's theories, she attempted to investigate abstraction mainly through the use of black and white. Her immediate concern was to focus on the way in which the eye perceives a field where different forces are at play and the way a painting serves to redefine this particular experience.[1]

In *Shuttle*, she explores the contrast between black and white to the utmost degree, arriving at a series of visual impressions through varying the size of the dots.

From the mid-1960s onwards she began to use colour, mainly shades of grey at first, as seen in *Metamorphosis*, where simple, rudimentary forms - circles in this case - take on a central role in this game of visual impressions through an act of repetition, gathering together in order to assert their presence. These forms open and close, expand or shrink, revolve around their axis, assemble at a certain point and disperse at another so that they may breathe. Thus, the viewer's eye is confused and cannot decide where to focus; it cannot trace the point where motion begins and can only perceive that motion is indeed carried through the canvas, spreading over the painting's surface, so that the work in its entirety becomes a source of visual stimuli.

In Riley's work we will find a language that has consciously been limited to the most basic of vocabularies (geometric patterns, circles, bands and stripes). Also, when observing her course, we can confirm her earnest passion for the act of 'seeing', as well as her thorough investigation of the concept and sense of 'seeing' that is ultimately identified with her work's subject.

The clarity of her thought, however, and the way this is economically transcribed on the canvas, does of course require an appropriate clarity of thought and perception on our part.

She, herself, explains: "In my previous works, created during the 1960s, I found that black and white along with shades of grey, behaved in the same way colours do; that is, they interacted and developed qualities such as contrast and radiance. There are myriads of senses and if one wishes to pass through them, then he must take the road of only one of them."

From the mid-1960s she used pure colour which transformed into

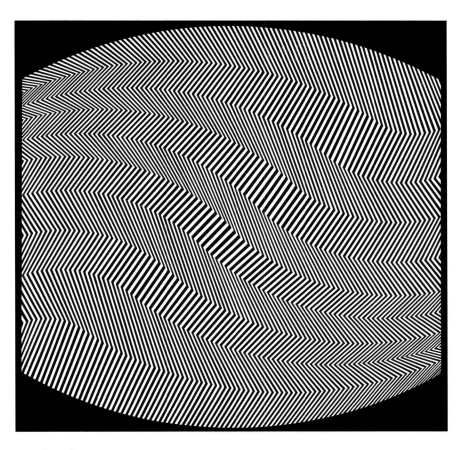

Shuttle

1964
EMULSION ON BOARD
112.5 X 112.5 cm
COLL. CAMJAP/CALOUSTE GULBENKIAN FOUNDATION, LISBON

a structural element for every composition. Her interest now focussed on the shape of colour, the power of light and the possibilities of vision. She pondered the nature of colour, its inherent motion and energy. Can the eye indeed perceive true light, true motion? Her work is the result of constant research based on a method of trial and error. Consequently, the viewer sees something whose undoubted quality is that of visual complexity, containing a surplus of past experience and present condition; he experiences a state of 'entrapment' into works that vibrate with energy, tension and colours that maintain their autonomy and completeness. For Riley, "the eye may wander over the painting's surface in a way similar to that by which it wanders over nature. It should feel caressed, experience friction and rupture; it should glide and drift… one moment there being nothing it can see, the canvas appearing full, the next, presenting a host of visual occurrences." In the end, Riley's works celebrate, but also challenge, one of the most important human senses: the power of seeing.

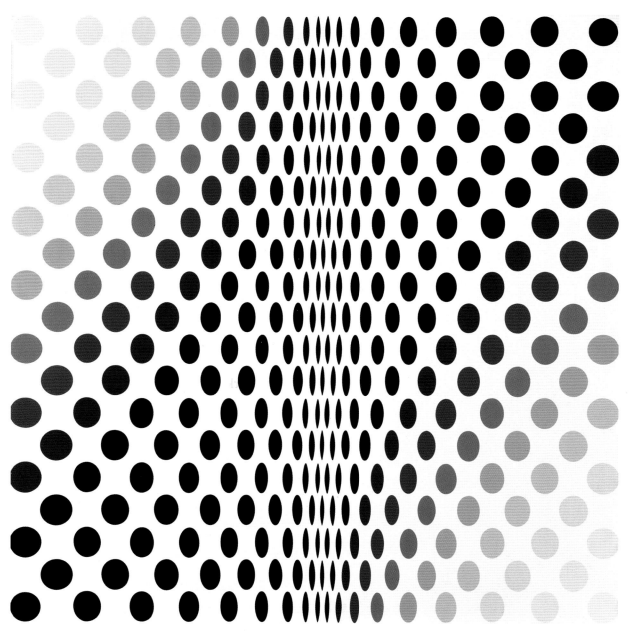

[1] Op Art (optical art) is one of the trends that developed in the realm of kinetic art. The characteristics of Op Art are to be found in the work's relationship to motion, since the motion created is not real. The first works that were representative of this trend took as a starting point the use of black and white (as is the case, for example, with works by Vasarely, Riley and others). This particular practice offers the possibility of producing maximum contrast and transcribes optical impressions, accurately defining form at the same time. The use of colour in this context revolves around the notions of simultaneous or consecutive contrast, tonality, the gradual alteration of colour, and perspective, to arrive ultimately at a visual blending of colours. In aesthetic terms, this is not to be seen as an art of illusion, but as an attempt at defining a purely visual concept of space that will yet once more challenge the notion of a single point of view.

Metamorphosis

1964
EMULSION ON BOARD
112.2 X 106.7 cm
COLL. CAMJAP/
CALOUSTE GULBENKIAN FOUNDATION, LISBON

Peter Sedgley

Peter Sedgley started off as an architect, but in the early 1960s he began painting, creating linear works at first that mostly featured bands of different sizes and tones of colour. He then moved on to concentric circles arranged in groups of colours, which he then spray painted so as to give them a soft colour coating and produce what he called "a motionless, [...] effect of movement".
Together with Riley, who was his partner between 1963 and 1973, he is considered to be one of the chief representatives of Op Art.

In later years his work became more 'kinetic'; however, he continued to be interested in the way light changes, in the paths it follows as it travels in between objects, in its relationship to the world around us. Visual games and the various ways of seeing would also continue to fascinate him.
He was interested in investigating the dual visual effect of colour and form so that he could arrive at a result that contains motion. He was particularly interested in colour, which he believes plays a key role in the way a field of vision is structured. He has created several geometric works consisting in the use of concentric circles, a pattern he seems to prefer since it allows a large concentration of colour. He uses bands of colour in different sizes and shades in his works, thus creating a visual blend, a sense of visual instability and an atmosphere of illusion.

In *Manifestation* we notice the particular attention with which the artist investigates the possibilities of Op Art. Against a thick black background, Sedgley draws a target-like pattern made up of numerous thin concentric circles painted in blue and a shade of reddish blue and stressed at certain points by the application of pure red. The image's outline has been rendered in such a way as to give the impression that this entire arrangement of circles moves or vibrates. The work has an almost hypnotic effect as circles appear to be leaving the canvas, leaping forward in the direction of the viewer and then retreating again. As with most works in the tradition of Op Art, here too a sense of motion is generated, although motion itself is not real. The viewer attempts to perceive this motion and enjoy the effect and power of light which spreads over and occupies the painting's entire surface.

Manifestation

1964
EMULSION ON BOARD
99.7 X 99.7 cm
COLL. CAMJAP/CALOUSTE GULBENKIAN FOUNDATION, LISBON

Colin Self

Colin Self's work constitutes a singular, highly sophisticated case in the context of Pop Art's development in Britain. Although the scenes he paints are directly related to the representational vocabulary of Pop and to its element of banality, Self indeed manages to invest his images with a dark, intimate quality that is infused with the sense of threat posed by man's aggressive, savage nature. His work contains a host of references to various areas of contemporary experience ⁄ ranging from the industry of the spectacle and American 'fast⁄food' culture, to the horror of nuclear weapons of mass destruction ⁄ which give it the character of a seeming act of protest against a social reality that has been oversaturated with technological advancements and consumerism. Nevertheless, Self did not aim to severely criticise the stereotypes of his own culture, but rather to record reality in a manner that was personal and highly emotional. Self sought to depict in his work the angst experienced by mankind due to the reality of the Cold War and the climate of radical political change, remaining at the same time obsessively committed to traditional painting practices, a thing that was rather unusual for his time. A series of small, delicate, labour⁄intensive, highly detailed drawings created in the mid⁄1960s present women and their role in contemporary urban environments.

In works such as *Block of Flats, Wolsey Road, Hornsey N8 and Woman in an Astrakhan Fur Coat*, the impressive figure of a woman of the upper classes, as suggested by her attire, seems to be gazing at a strictly geometric building that brings to mind London's working⁄class housing estates. The scale, use of perspective and intense symbolism evoking the male and female element create a highly charged field that contains elements of urban reality, conveying at the same time a dark, threatening sense that has its source in the realm of fantasy. In the series of drawings titled *Fall⁄Out Shelter* the artist also depicts women in the midst of an intimidating urban landscape, where the danger of nuclear destruction seems imminent.

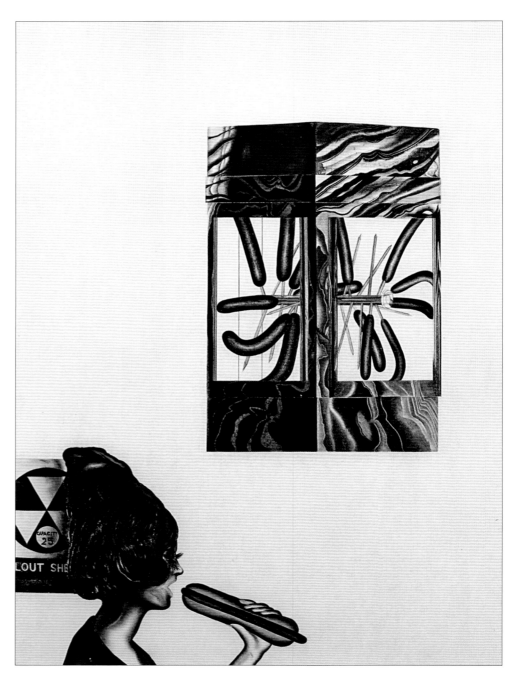

Fall-Out Shelter No. 4 - Infra-Red Frankfurter Roast and Eater

1965
PENCIL, COLOURED PENCIL AND FLUORESCENT COLLAGE ON PAPER
53.5 X 39 cm
BRITISH COUNCIL

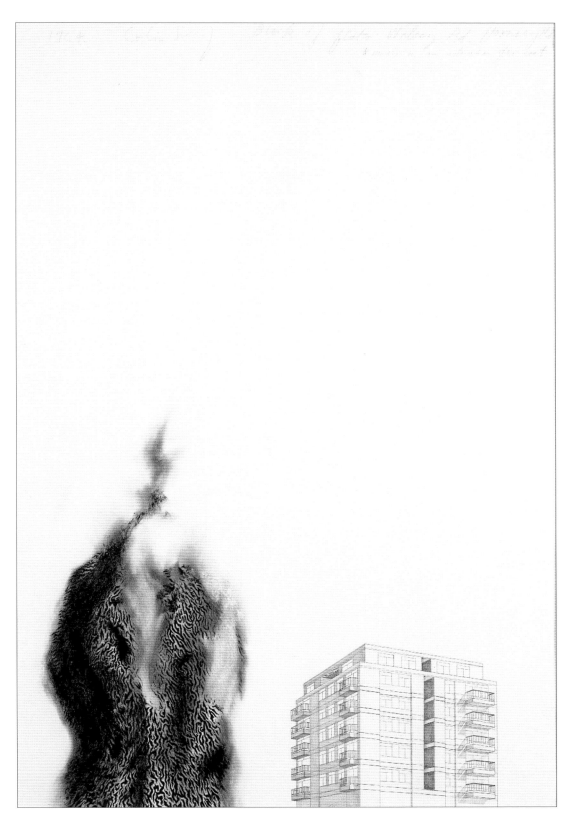

Self became familiar with the archetypal symbols of local American culture during two long trips to the USA; one which he took together with Hockney in 1962 and another one later on, in 1965.

In a drawing belonging to the *Fall-Out Shelter* series, entitled *Fall-Out Shelter No. 4 - Infra-Red Frankfurter Roast and Eater*, the everyday reality of American societies is depicted with a dose of sarcasm. At first glance the viewer encounters a simple everyday scene, only to ultimately realise that this is in fact a mocking rendition of the sense of corruption and insanity that Self detected everywhere around him in the large urban centres and countryside of the USA. The image is charged with sexual symbolism and reflects the sense of decadence that, according to Self, pervades contemporary societies.

Self's work is a snapshot of his age, a clear and brave record of perceptions that prevailed during that time. Because of his intensely personal, existential approach to contemporary life, he is understandably deemed, in the context of Pop Art's dominant trend, a 'romantic' artist.

In 1965, Self left the big city and settled in his home town of Norwich, England, where he continues to create works of a particularly personal and ambiguous character in terms of subject matter, of form and painting technique.

Block of Flats, Wolsey Road, Hornsey N8 and Woman in an Astrakhan Fur Coat

1964
PENCIL ON PAPER
55 X 36.8 cm
BRITISH COUNCIL

Richard Smith

Richard Smith's work oscillates between Pop Art and abstraction. During the late 1950s and together with other artists of the Situation Group (Robyn Denny, for instance) of which he was an active member, Smith espoused the formalist strategies and minimalist practice of American Abstract Expressionists ⁄ Rothko, Pollock, Francis ⁄ in terms of form, colour and arrangement.
Smith's two⁄year stay in New York during his studies (from 1959 to 1961) proved to be a landmark in the development of his painting practice. In the metropolitan landscape Smith came into close contact with photography and a complex system of mass culture images.

He automatically incorporated in his work a wide range of references from the realm of corporate slogans, posters used in advertising campaigns, fashion magazines, the movies and product packaging. Through this kind of material that was abundantly available, Smith examined the conceptual mechanisms used in advertising for the purpose of creating specific visual codes by means of which viewers might perceive messages related to consuming.

In the monumental canvases he created during that time, such as *Package*, he transformed the image of a cigarette pack into pure form and colour by means of a painting method resting solely on the use of the paintbrush. Through abstraction, Smith stresses the formalist quality inherent in all images of everyday life, and thus questions its communicative potential.

Smith shared Denny's enthusiasm for a kind of painting that would have an imposing, physical, almost sculptural presence in space. In *The Lonely Surfer* he creates a three⁄dimensional, panoramic environment. The canvas seems to expand indefinitely and ultimately becomes equivalent to an optical illusion.

In 1963, the artist created a new series of works in which niches and corners reach beyond the canvas into the work's surrounding space in the manner of sculptures. The canvas' surface is populated by images of packs that cover it both in terms of colour and volume. Smith's large, three⁄dimensional works impart a symbolically monumental character to the packages of consumer products of the time. They reflect the artist's ironic commentary of the way objects are viewed in the context of capitalist societies.
In the mid⁄1960s Smith abandoned the kind of subject matter offered by the era's ground⁄breaking iconography and once more began to independently process the formalist elements of abstraction.

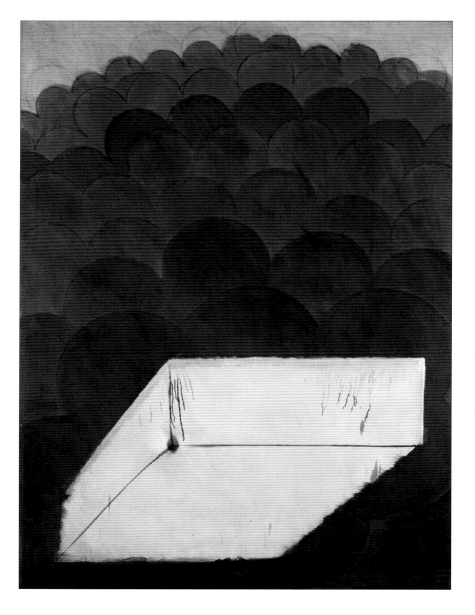

The Lonely Surfer

1963
OIL ON CANVAS
214 X 152.5 cm
COLL. CAMJAP/CALOUSTE GULBENKIAN FOUNDATION, LISBON

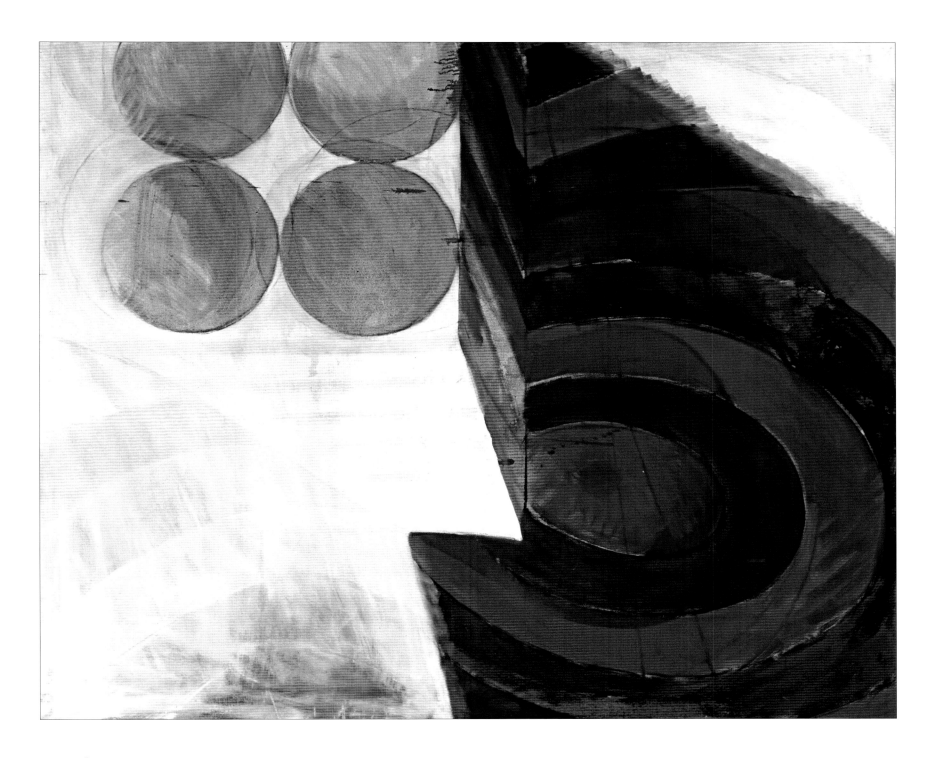

Package

1962
OIL ON CANVAS
173 X 213.5 cm
COLL. CAMJAP/CALOUSTE GULBENKIAN FOUNDATION, LISBON

Ian Stephenson

Influenced by artist Victor Pasmore ⁄ of whom he was also a student ⁄ Ian Stephenson sought to redefine the language of pure abstraction in a highly personal manner. Chiefly motivated by the wish to challenge the senses and to naturally engage the viewer in the experience of art, he created painted compositions over which the eye wanders following the movement of colour, without however being allowed to linger on any obvious point of reference. Due to their high density of colour and the intensely repetitive character of their lines, Stephenson's works acquire the proportions of illusory non⁄spaces. Below a seemingly inert surface, colour concentrates and lines move at a frenetic pace, so that his paintings ultimately hint at the birth of an idea and the existence of a secret narrative. Contrary to the practice of many artists of his time, who thoroughly explored the potential and prospects of the formalist elements of geometric abstraction, Stephenson formulated an exceptionally personal, independent style.

In *Giusti Allusion* silent symbolism and hidden details are revealed through superimposed layers of colour in the form of myriads of dots and lines. There is no definitive point of reference on the painting's surface and consequently there is no specific, prescribed way of looking at the composition. The viewer's gaze quickly shifts from one nebulous point on the painting's surface to the next, seeking for fields that can be 'read' and therefore provide some kind of interpretation. In a previous work, namely *Particular Shadows: Giusti 4*, the composition's dynamics also has its source in an explosion of colour, which creates an illusory impression of diffraction.

Stephenson's work functions as an intellectual stimulus for associations set forth by the subconscious. His paintings are dominated by uniform environments; by imaginary worlds in which questions regarding the relationship between the human field of vision and the rules that govern the creation of representation lie in wait.

Particular Shadows: Giusti 4

1960
OIL ON CANVAS
101.5 X 76 cm
COLL. CAMJAP/CALOUSTE GULBENKIAN FOUNDATION, LISBON

Giusti Allusion

1961
OIL ON CANVAS
127 X 127 cm
COLL. CAMJAP/CALOUSTE GULBENKIAN FOUNDATION, LISBON

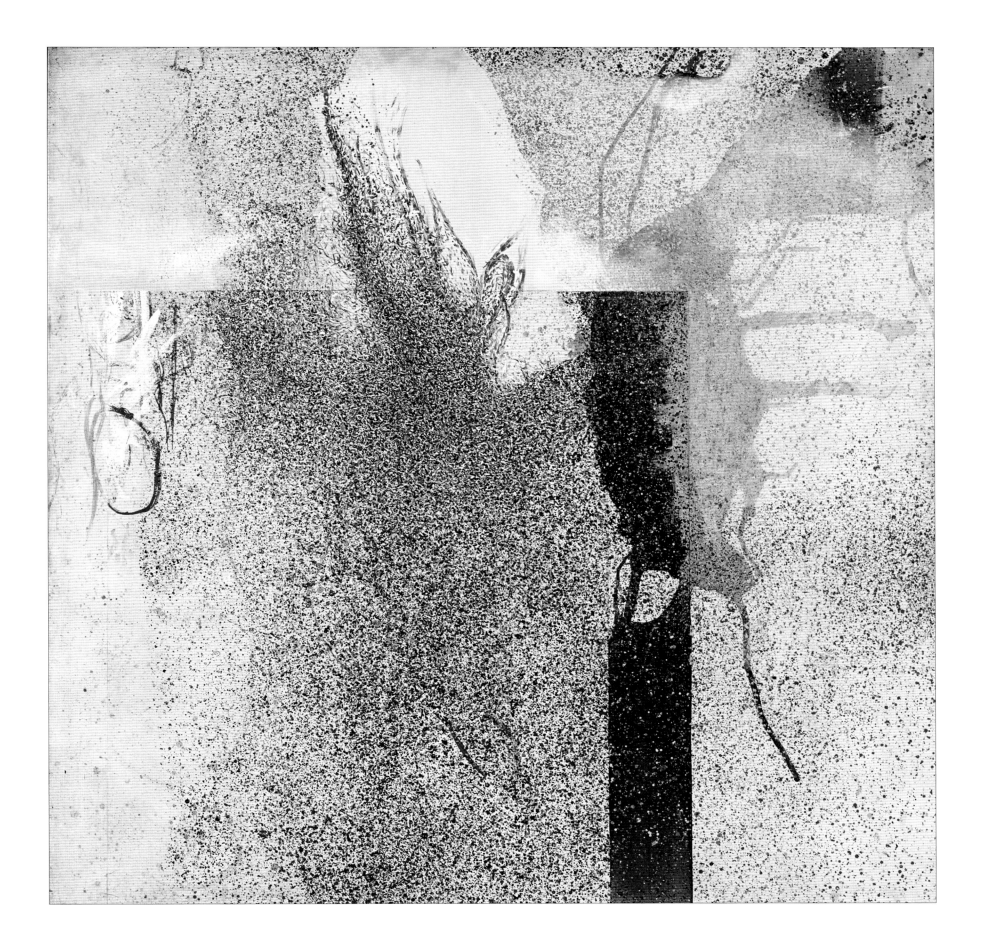

Joe Tilson

Joe Tilson's work is closely linked to that of first-generation British Pop artists, such as Peter Blake, Peter Phillips and David Hockney. During the 1960s, Tilson's iconographic vocabulary derived from the world of advertising, borrowed imagery related to the jukebox machine and assigned the role of images to words. Despite the fact that his early work, created in the late 1950s, reflected Tilson's interest in and experimentation with abstract painting, he would soon - especially at the beginning of the 1960s - focus on the subject matter of Pop Art and a kind of urban iconography, before subsequently developing a markedly personal style that gave his work a very particular, striking Pop identity.

In his works Tilson 'translated' the language of urban imagery and used advertising and children's toys, as well as the symbols of various products of mass consumption, to articulate the formalist character of his practice, which eventually acquired the form of wall-mounted compositions carved in wood. Through a highly resourceful use of a variety of different media - wood, plastic, photography, and the painted surface - he aimed to create impressive geometric motifs with a prominent decorative character, which combined with symbols alluding to everyday reality, consumer culture and the world of advertising. Tilson's familiarity with xylography - he had worked as a cabinet-maker from a very young age - allowed him to create objects carved in wood of a somewhat simplified and decorative character. He wished for the work of art to communicate with the viewer via simple optical codes; by means of attractive, multicoloured, glossy and clear geometric forms.

Compositions like *Xanadu* are a direct reference to totems or ancient monuments of sacred worship. Nevertheless, the tongue-in-cheek manner in which geometric surfaces are joined together, coupled with the warmth exuded by the wood and by the colour tones the artist uses, create a sculpturally unified form that also seems to resemble patterns found in contemporary urban reality.

From the late 1960s, Tilson began to process a wider range of iconographic material. By means of collage and the production of multiple prints, as well as screen prints, he began to work on themes that have their source in contemporary events.

Reverting heavily to irony, he introduced the element of representation in his practice and revealed his political views through the production of screen prints in relief that depict figures of major political leaders such as Che Guevara and Ho Chi Minh. From around mid-1972, Tilson began to directly oppose the values and ways of contemporary life; he distanced himself from all kinds of experimentation and avoided the use of new methods and technologies, opting to work instead with motifs which he borrowed from classical mythology and employing traditional methods of production like engraving and xylography.

Starship Trooper

1961
RELIEF CONSTRUCTION
IN WOOD AND PVA
33.5 X 41 X 7 cm
COLL. CAMJAP/
CALOUSTE GULBENKIAN
FOUNDATION, LISBON

Multiple Painting - Twin

1962
PAINTED WOOD
CONSTRUCTION
60 X 90 X 2.5 cm
COLL. CAMJAP/
CALOUSTE GULBENKIAN
FOUNDATION, LISBON

Xanadu

1962
PAINTED WOOD
AND METAL RELIEF
199 X 160 X 11.5 cm
COLL. CAMJAP/
CALOUSTE GULBENKIAN
FOUNDATION, LISBON

Isaac Witkin

Isaac Witkin belongs to that avant-garde group of British sculptors who introduced new methods and practices with their work during their study at St Martin's School of Art at the beginning of the 1960s and under the supervision and guidance of established sculptor Anthony Caro, thus radically redefining the concept of sculpture. They adopted a revolutionary approach to sculpture that distanced them from the then recent past of the Modernist tradition. And by introducing new media into their practice, mainly the use of synthetic materials from the realm of industrial production, they opened up a new, experimental dimension in the way everyday life was depicted through sculpture. The, by now, historical *New Generation* exhibition presented at the Whitechapel Art Gallery in 1965 and organised by Bryan Robertson, the foundation's director, featured all trends in sculpture being developed at the time by these new and talented artists, while it aptly conveyed the experimental, avant-garde character of these trends. In the period that followed, all artists of the so called New Generation Group went on to delineate their own, autonomous course in art. Witkin also sought to express the autonomy of his artistic vision in works made of glass or wood, which however retained some characteristics of traditional sculpture, although he did share common preoccupations with artists of his generation. As Judith Winter notes, Witkin never accepted the idea that the notion of sculpture's autonomy presupposed an exclusively formalist practice, as did some of his peers. He considered the elimination of all external references unfeasible and believed that sculpture must always possess an emotionally charged presence.

Volution, a work made of fibreglass, sums up several of the artist's intentions at the time. "I like to capture the essence of a primary, dynamic force - tension, motion, rhythm, or growth - and preserve it at that point in time when it reaches its climax." An abstract form that takes the shape of a spiral, occupies space by asserting its ascending course. The material's shining light-green colour, which is one of its integral features, imparts a sense of uniformity to the work's form.

Witkin's practice changed radically during the 1970s, which was also due to the fact that the artist had now left Britain and settled in the USA (he became an American citizen in 1975). He began discovering new ways of approaching and developing his sculptural language. Among these, the use of bronze, but also of sand, as the chief material that enables an approach of the 'controlled accident' phenomenon, seems quite remarkable.

Volution

1964
FIBREGLASS
250 X 46 X 86 cm
COLL. CAMJAP/
CALOUSTE GULBENKIAN FOUNDATION,
LISBON

LIST OF WORKS

David Annesley

Swing Low, 1964
Painted steel,
129.5 x 162 x 30.5 cm
Coll. CAMJAP/Calouste Gulbenkian
Foundation, Lisbon

Untitled, c. 1962
Pastel on paper
55 x 75.4 cm
Coll. CAMJAP/Calouste Gulbenkian
Foundation, Lisbon

Gillian Ayres

Untitled, 1965
Four oil crayon drawings on paper
Framed together
55 x 53 cm
Coll. CAMJAP/Calouste Gulbenkian
Foundation, Lisbon

Stamboul, 1965
Acrylic on canvas
122.5 x 122.5 cm
Coll. CAMJAP/Calouste Gulbenkian
Foundation, Lisbon

Send Off, 1962
Oil on canvas
213 x 305 cm
Coll. CAMJAP/Calouste Gulbenkian
Foundation, Lisbon

Peter Blake

Five pencil drawings on paper, 1961-1967
Framed together

Bertram Mills, 1961
Pencil
21.5 x 12.6 cm
British Council

Bertram Mills, 1961
Pencil
28 x 20.3 cm
British Council

Jimmy Scott, Bertram Mills, 1961
Pencil
21.5 x 13.3 cm
British Council

Bertram Mills, 1961
Pencil
21 x 21.5 cm
British Council

Bertram Mills, Circus Season, 1967
Pencil
23 x 15 cm
British Council

The Love Wall, 1961
Collage and wood relief construction
125 x 237 x 23 cm
Coll. CAMJAP/Calouste Gulbenkian
Foundation, Lisbon

Michael Bolus

Bowbend, 1964
Painted steel
122 x 137 x 65 cm
Coll. CAMJAP/Calouste Gulbenkian
Foundation, Lisbon

Derek Boshier

Untitled, 1965
Felt pen on paper
73.4 x 103.8 cm
Coll. CAMJAP/Calouste Gulbenkian
Foundation, Lisbon

Out, 1964
Oil on shaped canvas
152 x 237 cm
Coll. CAMJAP/Calouste Gulbenkian
Foundation, Lisbon

So Ad Men Became Depth Men, 1962
Oil on canvas
153 x 153 cm
Coll. CAMJAP/Calouste Gulbenkian
Foundation, Lisbon

Anthony Caro

Pink Stack, 1969
Painted steel
120 x 335.5 x 147.5 cm
British Council

Patrick Caulfield

Artist's Studio, 1964
Oil on board
91.4 x 281.4 cm
Arts Council Collection, Hayward
Gallery, South Bank Centre, London

View of the Bay, 1964
Oil on board
122 x 183 cm
Coll. CAMJAP/Calouste Gulbenkian
Foundation, Lisbon

Bernard Cohen

Drawing Imperial I, 1962
Pastel on paper
52.5 x 63.5 cm
Coll. CAMJAP/Calouste Gulbenkian
Foundation, Lisbon

Drawing Imperial II, 1962
Pencil and coloured crayon on paper
52.5 x 63.5 cm
Coll. CAMJAP/Calouste Gulbenkian
Foundation, Lisbon

Mist, 1963
Oil and tempera on canvas
152.5 x 152.5 cm
Coll. CAMJAP/Calouste Gulbenkian
Foundation, Lisbon

Barrie Cook

Continuum, 1971
Spray paint on paper
78 x 138 cm
Coll. CAMJAP/Calouste Gulbenkian
Foundation, Lisbon

Robyn Denny

Jones' Law 1964, 1964
Oil on canvas
214 x 183.5 cm
Coll. CAMJAP/Calouste Gulbenkian
Foundation, Lisbon

Antony Donaldson

Summershot, 1964-1965
Acrylic on canvas
172 x 172 cm
Coll. CAMJAP/Calouste Gulbenkian
Foundation, Lisbon

Garth Evans

White, 1965
Painted fibreglass
123 x 140 x 9 cm
Coll. CAMJAP/Calouste Gulbenkian
Foundation, Lisbon

Richard Hamilton

People, 1968
Photograph, screenprint, letratone and
collage on paper
65 x 84 cm
Coll. CAMJAP/Calouste Gulbenkian
Foundation, Lisbon

Swingeing London 67 - Etching, 1968
Etching, aquatint, embossing and collage
on paper
56.5 x 72.7 cm
Coll. CAMJAP/Calouste Gulbenkian
Foundation, Lisbon

The Critic Laughs, 1968
Laminated photo-offset lithograph with
screenprint, enamel paint and collage on
paper
59.3 x 46.5 cm
British Council

Chicago Project I, 1969
Acrylic on photograph on board
81.3 x 122 cm
British Council

Chicago Project II, 1969
Oil on photograph on board
81.3 x 122 cm
British Council

Bathers (a), 1967
Screenprint
70.5 x 94.5 cm
British Council

A Portrait of the Artist by Francis Bacon,
1970-1971
Collotype and screenprint
82 x 69.2 cm
British Council

David Hockney

Figure in Helmet and Cloak, 1963
Ink on paper
50.5 x 31.8 cm
Coll. CAMJAP/Calouste Gulbenkian
Foundation, Lisbon

Pigs Escaping from a Hot Dog Machine, 1961
Ink on paper
45.5 x 60.5 cm
Coll. CAMJAP/Calouste Gulbenkian
Foundation, Lisbon

Renaissance Head, 1963
Oil on canvas
122 x 122 cm
Coll. CAMJAP/Calouste Gulbenkian
Foundation, Lisbon

*Man in a Museum (or you're in the wrong
movie)*, 1962
Oil on canvas
147.3 x 152.4 cm
British Council

Howard Hodgkin

Mr and Mrs Patrick Caulfield, 1967-1970
Oil on canvas
107 x 127 cm
Coll. CAMJAP/Calouste Gulbenkian
Foundation, Lisbon

John Hoyland

No. 19, 26.12.1961, 1961
Oil on canvas
244 x 213.5 cm
Coll. CAMJAP/Calouste Gulbenkian
Foundation, Lisbon

8.8.63, 1963
Oil on canvas
173 x 173 cm
Coll. CAMJAP/Calouste Gulbenkian
Foundation, Lisbon

Paul Huxley

Untitled No. 36, July-November 1964, 1964
Oil on canvas
173 x 173 cm
Coll. CAMJAP/Calouste Gulbenkian
Foundation, Lisbon

Allen Jones

Parachutist No. 2, 1963
Oil on canvas
209.5 x 124.5 cm
Coll. CAMJAP/Calouste Gulbenkian
Foundation, Lisbon

"Dance with the Head and the Legs...", 1963
Oil on canvas
183 x 152 cm
Coll. CAMJAP/Calouste Gulbenkian
Foundation, Lisbon

Michael Kidner

Brown, Blue and Violet No. 2, 1964
Acrylic on canvas
124.5 x 152.5 cm
Coll. CAMJAP/Calouste Gulbenkian
Foundation, Lisbon

Phillip King

Ripple, 1963
Plastic
188 x 89 x 77 cm
Coll. CAMJAP/Calouste Gulbenkian
Foundation, Lisbon

Jeremy Moon

Drawing 71/77, 1971
Pastel on paper
20.3 x 25.3 cm
British Council

Concord, 1964
Acrylic on canvas
112 x 387 cm
Coll. CAMJAP/Calouste Gulbenkian
Foundation, Lisbon

Eduardo Paolozzi

Mask, 1957
Screenprint and collage on paper
68.5 x 50 cm
British Council

Dollus I, 1967
Chrome plated steel
128.9 x 78 x 15.9 cm
British Council

Diana as an Engine I, 1963-1966
Painted aluminium
193.7 x 97.5 x 53.3 cm
British Council

Peter Phillips

For Men Only - Starring MM and BB, 1961
Oil, wood and collage on canvas
259.6 x 153.1 cm
Coll. CAMJAP/Calouste Gulbenkian
Foundation, Lisbon

INsuperSET, 1963
Oil and hardboard inlays on canvas
217.5 x 157 cm
Coll. CAMJAP/Calouste Gulbenkian
Foundation, Lisbon

John Plumb

Needles, 1963
Oil on canvas
152.5 x 152.5 cm
Coll. CAMJAP/Calouste Gulbenkian
Foundation, Lisbon

Bridget Riley

Shuttle, 1964
Emulsion on board
112.5 x 112.5 cm
Coll. CAMJAP/Calouste Gulbenkian
Foundation, Lisbon

Metamorphosis, 1964
Emulsion on board
112.2 x 106.7 cm
Coll. CAMJAP/Calouste Gulbenkian
Foundation, Lisbon

Peter Sedgley

Manifestation, 1964
Emulsion on board
99.7 x 99.7 cm
Coll. CAMJAP/Calouste Gulbenkian
Foundation, Lisbon

Colin Self

Fall-Out Shelter No. 4 - Infra-Red Frankfurter Roast and Eater, 1965
Pencil, coloured pencil and fluorescent collage on paper
53.5 x 39 cm
British Council

Block of Flats, Wolsey Road, Hornsey N8 and Woman in an Astrakhan Fur Coat, 1964
Pencil on paper
55 x 36.8 cm
British Council

Richard Smith

The Lonely Surfer, 1963
Oil on canvas
214 x 152.5 cm
Coll. CAMJAP/Calouste Gulbenkian
Foundation, Lisbon

Package, 1962
Oil on canvas
173 x 213.5 cm
Coll. CAMJAP/Calouste Gulbenkian
Foundation, Lisbon

Ian Stephenson

Particular Shadows: Giusti 4, 1960
Oil on canvas
101.5 x 76 cm
Coll. CAMJAP/Calouste Gulbenkian
Foundation, Lisbon

Giusti Allusion, 1961
Oil on canvas
127 x 127 cm
Coll. CAMJAP/Calouste Gulbenkian
Foundation, Lisbon

Joe Tilson

Starship Trooper, 1961
Relief construction in wood and PVA
33.5 x 41 x 7 cm
Coll. CAMJAP/Calouste Gulbenkian
Foundation, Lisbon

Multiple Painting - Twin, 1962
Painted wood construction
60 x 90 x 2.5 cm
Coll. CAMJAP/Calouste Gulbenkian
Foundation, Lisbon

Xanadu, 1962
Painted wood and metal relief
199 x 160 x 11.5 cm
Coll. CAMJAP/Calouste Gulbenkian
Foundation, Lisbon

Isaac Witkin

Volution, 1964
Fibreglass
250 x 46 x 86 cm
Coll. CAMJAP/Calouste Gulbenkian
Foundation, Lisbon

BIOGRAPHICAL NOTES

David Annesley was born in London in 1936 and grew up in Britain, Australia and Zimbabwe. Following his military service as a pilot in the RAF (1956-1958), he studied painting and sculpture at St Martin's School of Art under the supervision of Anthony Caro (1958-1962).
From 1963 to 1995 he taught in various schools (Croydon College of Art, the Central School of Art, St Martin's School of Art and the Royal College). From 1978 to 1995 he held the post of external examiner at the Manchester Polytechnic, Croydon College, the Wimbledon School of Art and the Crawford College of Art in Cork, Northern Ireland. In 1995 he was elected a member of the Royal British Society of Sculptors.
His first solo exhibition was held in 1966 at the Waddington Gallery. It was followed by numerous solo shows in London, New York, the Netherlands, Germany and Australia. Works of his were included in the *Young Contemporaries* exhibition, held in London in 1961, and the renowned *New Generation* exhibition held at the Whitechapel Art Gallery in 1965.
His works are included in a number of public collections, namely: the Arts Council, the British Council, Tate Gallery (London), MoMa (New York), Nagoya Gallery (Japan) and the Gallery of New South Wales (Australia).

Gillian Ayres was born in London in 1930. When she was fourteen she decided to be a painter. From 1946 to 1950 she studied at Camberwell School of Art, then worked as a housemaid in Cornwall and later got a job at a bookstore in London. From 1959 to 1981 she taught at various schools (Bath Academy of Art, St Martin's School of Art and Winchester School of Art) and then settled in Wales where she dedicated herself exclusively to painting.
In 1951 she participated in the *Young Contemporaries* exhibition and started working at the AIA Gallery where she met her future husband, painter Henry Mundi. Her first solo exhibition was held in 1956 at One Gallery, London. A great number of group shows would follow.
In 1963 she participated in *British Painting in the 60s*, held at the Whitechapel Art Gallery.
The record of her solo exhibitions is impressive: the

Museum of Modern Art, Oxford (1981), the Serpentine Gallery (1983), Tate Gallery (1995) and the Royal Academy (1997), all in London. Her work has been shown in several countries such as France, Italy, Germany, Denmark, Switzerland, New Zealand, Australia, USA and Japan.

Peter Blake was born in Dartford, Kent, in 1932. He studied graphic arts at the Gravesend Technical College (1946-1949) and the Gravesend School of Art (1949-1951). From 1953 to 1956 he studied at the Royal College of Art. During, and immediately after, his studies there he created his first works that can be defined 'Pop'.
For one year (1956-1957) he travelled throughout Europe on a scholarship for the purpose of studying various forms of popular art. From 1960 to 1964 he taught at St Martin's School of Art, the Harrow School of Art and the Walthamstow School of Art. From 1964 to 1976 he taught at the Royal College of Art.
In 1975 he moved to Wellow, near Bath (where he would stay until 1979), and there he formed 'The Brotherhood of Ruralists' together with six friends. He created a series of paintings in the style of realistic representation, whose images are rooted in the world of fantasy, and whose themes are inspired by literature and contemporary affairs. In 1981 he was elected a member of the Royal Academy and in 2002 received a knighthood from the Queen.

Michael Bolus was born in Cape Town, South Africa. He moved to England in 1957 and studied at St Martin's School of Art (1958-1962) alongside David Annesley, Phillip King, Tim Scott, William Tucker and Isaac Witkin, who, in 1952, under the supervision of their teacher Anthony Caro and the guidance of Frank Martin, then head of the department of sculpture and a highly inspired individual, undertook the teaching of a course in 'advanced sculpture'.

Derek Boshier was born in Portsmouth in 1937. He studied at the Yeovil School of Art in Somerset from 1953 to 1957, the Guildford College of Art from 1957 to

1959 and the Royal College of Art from 1959 to 1962 together with Hockney, Jones, Phillips and Caulfield.
In 1959 he participated in the *Young Contemporaries* exhibition held at the RBA Galleries in London. His first solo exhibition took place in 1959 at the Grabowski Gallery in London. His works were included in Pop Art exhibitions in The Hague, Vienna and Berlin.
In 1962 he travelled to India on a scholarship for a year.
In 1966 he abandoned painting and started working on sculpture, photography and collage, without however losing interest in political and social issues; the destructive aspect of advertising continued to concern him.
In 1963 he taught at the Central College of Art and Design and at the Hornsey College of Art in London.
In 1973 he taught at the Royal College of Art in London and later on, in 1975, at the University of Victoria in Vancouver, Canada, as visiting professor. In 1979 he began to paint again and in 1980 taught at the Department of Painting, University of Houston, as assistant professor.

Anthony Caro was born in New Malden, Surrey. He studied engineering at Christ's College, Cambridge (1942-1944), and during vacations worked alongside sculptor Charles Wheeler. He joined the Royal Navy's Fleet Air Arm during World War II where he served as Air Marshal. After the war he studied at the Regent Street Polytechnic (1946-1947) and the Royal Academy Schools (1947-1952). Between 1951 and 1953 he worked as assistant to Henry Moore and began teaching sculpture at St Martin's School of Art, where he continued to teach until 1979.
The public was first introduced to his radical views through an exhibition of his work at London's Whitechapel Art Gallery in 1963. His work has been presented since in retrospective exhibitions held at major international museums, institutions and art biennials, which include among others New York's Museum of Modern Art (1975), Tokyo's Museum of Contemporary Art (1995) and the Venice Biennale (1999). He has also presented important solo exhibitions such as *Sculpture into Architecture*, held at the Tate Gallery (1991), and *Sculpture from Painting*, held at the National Gallery (1998) in London.
Caro has received major awards and prizes for his work

such as the Praemium Imperiale award for sculpture (Tokyo, 1992) and the Lifetime Achievement Award for Sculpture (1997). In 1987 he was knighted by the Queen and in 2000 was honoured with the Order of Merit. Recently, in January 2005, the Tate Gallery held a major exhibition of his work featuring both new and older works.

Patrick Caulfield was born in London in 1936 and studied at the Chelsea School of Art (1956-1960) and the Royal College of Art (1961-1963), where he met Hockney, Kitaj and Allen Jones.
In 1964 he participated in the *New Generation* exhibition held at the Whitechapel Art Gallery, while his first solo exhibition was held at the Robert Fraser Gallery in London in 1965.
From 1963 to 1971 he taught at the Chelsea School of Art. In 1984 he designed the sets and costumes for a performance of Martin Corder's ballet *Party Game*, which was staged at the Royal Opera House in Covent Garden. In 1991 he designed the carpet for the atrium of the British Council offices in Manchester. In 1994, he designed a gigantic mosaic entitled *Flowers, Lily Pad, Pictures and Labels* for the National Museum of Wales in Cardiff. In 1995 he designed the set and costumes for a production of Frederick Ashton's *Rhapsody* presented at the Royal Opera House in Covent Garden.
His works are included in a number of public collections such as: the Harry N. Abrams Collections, New York; the Arts Council of Great Britain; the British Council; the Tate Gallery and the Victoria and Albert Museum, London; the Kunsthalle Bielefeld, Germany; the Scottish National Gallery of Modern Art, Edinburgh; the Tochigi Prefectural Museum of Fine Arts, Japan, and others.

Bernard Cohen was born in London in 1933. He began by taking courses in shorthand and typing at Clark's College (1947), but eventually studied Fine Arts at the South West Essex Technical College from 1949 to 1950, at St Martin's School of Art from 1950 to 1951 and at the Slade School of Fine Art from 1951 to 1954. Between 1954 and 1956 he travelled to Paris and Rome on scholarships from the French Government and the University of London. His first solo exhibition was held

at the Gimpel Fils Gallery, London, in 1953.
He has presented many solo exhibitions and has also participated in many group shows. His works are found in a number of public collections worldwide, among others: the Arts Council of Great Britain; the British Council; the Tate Gallery and the Victoria and Albert Museum, London; MoMA, New York; and the National Gallery of Canada, Ottawa.

Barrie Cook was born in Birmingham in 1929. He studied at the Birmingham College of Art (1949-1954). From 1954 to 1961 he taught in secondary schools and from 1961 to 1962 was a lecturer at the Coventry College of Art. He was head of the Fine Arts Department at Stourbridge College of Art from 1969 to 1974. He taught painting at the Cardiff College of Art (1974-1977), was Gregynog Fellow at the University of Wales (1977-1978) and from 1979 to 1983 was head of the Fine Arts Department at the Birmingham Polytechnic. His work has been presented in numerous solo and group exhibitions, (such as the Whitechapel Art Gallery and the Serpentine Gallery), while an impressive retrospective was presented at the Barbican Centre Concourse Gallery in London (1995).
Works by Cook are included in several public collections such as the Tate Gallery, London, and the Arts Council of Great Britain, among others.

Robyn Denny was born in Abinger, Surrey, in 1930. He studied at St Martin's School of Art (1951-1958) and the Royal College of Art (1953-1957). Following his first solo exhibition in 1958, Denny presented his work in various museums and private galleries worldwide.
He participated both as an artist and as an organiser in the 1960 and 1961 *Situation* exhibitions at London's ICA (Institute of Contemporary Art). He represented Britain in Contemporary Art Biennials held in Paris, Tokyo, Milan, Brussels, Australia and the USA, as well as in the XXXIII Venice Biennale.
His works are included in major public and corporate collections, such as the Tate Gallery in London (he was the youngest artist ever to have a retrospective exhibition

in the Tate Gallery, in 1973, which toured many European cities through the British Council); MoMa, New York; the Chicago Art Institute and the Yale Centre for British Art in the USA.

Antony Donaldson was born in Godalming, Surrey. He studied at the Slade School of Art (1959-62) and received his post-graduate degree from the University of London in 1962. In the same year he was appointed President of the *Young Contemporaries* annual Fine Arts student show and began teaching at the Chelsea School of Art, together with Patrick Caulfield and Allen Jones. His first solo exhibition was held at the Rowan Gallery in London (1963). He participated in many pioneering group shows, such as *Young Contemporaries* and *New Generation* held at the Whitechapel Art Gallery. In the period between 1966 and 1968 he travelled to the United States, settled in Los Angeles and became accustomed to the carefree way of life of Southern California. He presented his work at the Nicholas Wilder Gallery in Los Angeles and in 1968 returned to London where he continues to work.

Garth Evans was born in Cheshire. He studied at the Manchester Junior College of Art (1949-1951), the Manchester Regional College of Art (1955-1957) and the Slade School of Art (1957-1960). His first solo exhibition was held at the Rowan Gallery in London. In 1979 he moved to the USA.

Richard Hamilton was born in London, where he also pursued his academic studies in intermittent cycles at different academic establishments (Westminster Technical College, St Martin's School of Art, the Royal Academy Schools, and the Slade School of Art), alternating with periods of work, some of which proved to be very important for his development and career as an artist. His first solo exhibition was held in 1950 at the Gimpel Fils Gallery in London.
In 1952 and while teaching typography and industrial design at the Central School of Arts and Crafts he met Eduardo Paolozzi and together they founded the

Independent Group at London's ICA (Institute of Contemporary Art). In 1956 he created his first Pop collage for the poster and catalogue accompanying *This Is Tomorrow*, a ground-breaking exhibition held at the Whitechapel Art Gallery; this work established him as a founder of the movement of Pop Art. From 1957 to 1961 he taught interior design at the Royal College of Art. In 1963 he travelled to the USA for the first time. In 1974, important international museums, such as New York's Guggenheim Museum and Munich's Städtische Gallery organised major solo exhibitions featuring his work. The first major retrospective exhibition of his work was held in 1979, at the Tate Gallery in London.

David Hockney was born in Bradford, Yorkshire, in 1937. He studied at the Bradford School of Art (1953-1957) and the Royal College of Art (1959-1962). From 1957 to 1959 he did social work in various hospitals as he was a conscientious objector and refused to do military service.
In 1961 he participated in the *Young Contemporaries* exhibition and was immediately recognised as one of the leading figures in the Pop Art movement. In the same year he travelled to New York, where he was struck by the freedom that characterised American society. He began to project a new image of himself, which also owed much to his discovery of the poetry of Walt Whitman and C. P. Cavafy.
In 1962 he taught at the Mainstone College of Art, and at the University of Colorado and the University of California, Berkeley, from 1965 to 1967.
He also visited Italy, Berlin and Egypt, and in California would revise his practice, from 1963, increasingly turning towards a use of acrylics and photography and creating several engravings. The lifestyle and landscapes of Los Angeles were to become an important part of his work. In 1968 he returned to Britain and in 1970 London's Whitechapel Art Gallery presented a major retrospective exhibition of his work. The 1988 retrospective held in Los Angeles would also travel to New York and London. The work he has produced for the theatre is a significant part of his highly versatile creative practice. He designed the sets and costumes for a production of Jarry's *King Ubu* presented at London's Royal Court Theatre (1966),

Stravinsky's *The Rake's Progress* (1974, Glyndebourne Festival), Mozart's *The Magic Flute* (1978, Glyndebourne Festival), Wagner's opera *Tristan and Isolde* at the New York Metropolitan Opera, Puccini's *Turandot* at the San Francisco Opera and Strauss' *Die Frau ohne Schatten* [Woman Without a Shadow] at Covent Garden. During the 1980s he focussed mostly on photo-collage, and also began to create a series of portraits. During the 1990s he showed particular interest in new technologies and the way in which these may serve artistic expression.

Howard Hodgkin was born in London in 1932. In 1940 he moved to Long Island, USA, and stayed there until the end of World War II. Later, while a student at Eton College, he was encouraged by Wilfred Blunt, his art teacher, to imitate the Fauvists. Blunt introduced him to the work of the Rajput of Rajasthan and Moghul culture, which was a true revelation for Hodgkin and its influence was evident both in his painting (whose sense of colour and arrangement was very close to that of the Indian miniaturists) and in his own collection of Indian miniature painting. In 1947 he returned to Long Island and that summer, influenced by the work of Vuillard, Matisse, Stuart Davies and Egon Schiele, as well as by erotic Indian miniatures, he painted *Memories*. Following his return from the USA, he studied at Bryanston School, Camberwell School of Art (1949-1950) and Bath Academy of Art (1950-1954). His first solo exhibition was held at the Arthur Tooth & Sons Gallery in 1962, while in 1963 he participated in the *British Painting in the 1960s* exhibition held at the Whitechapel Art Gallery.
He presented numerous solo exhibitions and participated in numerous group shows. From 1966 to 1972 he taught at the Chelsea School of Art. He served as a trustee of the Tate Gallery from 1970 to 1976 and a trustee of the National Gallery from 1978 to 1985. In 1984 he represented Britain in the XLI Venice Biennale. In 1985 he was awarded the Turner Prize and in 1992 he received a knighthood. In 1999 he became an honorary member of the London Institute and in 2000 he was given the title of professor emeritus at the University of Oxford.

John Hoyland was born in Sheffield, Yorkshire, in 1934. He studied at the Sheffield College of Art (1956-1960) and the Royal Academy Schools (1956-1960). He was influenced by the work of artist Nicolas de Staël and in 1954 began painting abstract landscapes and still lifes. He embarked on a more systematic investigation of colour while at Scarborough Summer School (1957), where he was a student of Victor Pasmore, Tom Hudson and Harry Thubron. During a trip to New York he met American painters Helen Frankenthaler, Kenneth Noland and Jules Olitski, while critic Clement Greenberg introduced him to the work of Hans Hoffman and Morris Louis.
In Britain he participated in the 1960 and 1961 *Situation* exhibitions, in which he presented his first exclusively abstract works, such as *Situation*. He also participated in the crucial *New Generation* exhibition held in 1964 at the Whitechapel Art Gallery. In the same year he also presented his first solo exhibition at the Marlborough New London Gallery.

Paul Huxley was born in London. He studied at Harrow College of Art (1949-1951), Harrow School of Art (1951-1953) and the Royal Academy Schools (1956-1960). In 1959, he participated in the *Young Contemporaries* exhibition held at the RBA Galleries in London. In 1964 he was awarded first prize at the *New Generation* exhibition organised by Bryan Robertson at the Whitechapel Art Gallery. In 1965 he was awarded a Harkness Fellowship that would allow him to work in New York as artist-in-residence.
His works have been included in exhibitions such as *British Painting 1952-1977*, held at the Royal Academy, and *British Art 1940-1980* held at the Hayward Gallery in 1980, both in London. His first solo exhibition was held at the Rowan Gallery in London in 1963. Among his important solo exhibitions was the one held in 1974 at the Galeria de Emenda in Lisbon.

Allen Jones was born in Southampton in 1937. He studied at the Hornsey College (1956-1959 and 1960-1961) and at the Royal College of Art (1959-1960). He taught at London's Croydon College of Art (1961-1963)

and Chelsea School of Art in 1964. For three consecutive decades he held the post of professor emeritus at many reputable academic establishments.

Jones was active in many fields of the arts, such as painting, sculpture, design and engraving and from 1970 he began designing the sets and costumes for a number of television shows and theatre performances. His first solo exhibition was held in London in 1963 at the Arthur Tooth & Sons Gallery. In 1979, Liverpool's Walker Art Gallery organised a major retrospective exhibition of his work, which then travelled to London's Serpentine Gallery, to Sunderland, Baden-Baden and Bielefeld. In 1981 he was elected an honorary member of London's Royal Academy.

Michael Kidner was born in Kettering, Northamptonshire. He studied history and anthropology at the University of Cambridge (1936-1939) and environmental design at the University of Ohio, USA (1940-1941). In 1946, he attended courses at Goldsmiths College, London. He taught in Scotland for a few years, painting landscapes at the same time, and then moved to Paris where he attended classes at André Lhote's studio. Upon his return to England, he settled in Devon and then Cornwall, where he became acquainted with Patrick Heron, Roger Hilton, Terry Frost and Peter Lanyon, before returning to London.

He has participated in many important exhibitions, such as *Systems* held at the Whitechapel Art Gallery in 1972, and *British Painting 1952-1977* held at the Royal Academy of Arts in 1977. In 1984, London's Serpentine Gallery organised a major retrospective exhibition of his work, while his solo exhibition held in 1987 at the Amon Anderson Gallery in Helsinki was equally important.

Phillip King was born in Tunisia in 1934. He studied modern languages at Christ's College, Cambridge (1954-1957), and attended courses at St Martin's School of Art (1957-1958) attracted by the fact that Anthony Caro was teaching there. From 1959 to 1960 he worked as assistant to Henry Moore and for a short while also to Paolozzi. In 1960 he won a scholarship and travelled to Greece to study the symbiotic relationship between ancient art and architecture and a developing environment. In 1968 he represented Britain in the XXXIV Venice Biennial.

He taught at St Martin's School of Art (1959-1978) and at the Slade School of Fine Art in London (1967-1968); from 1967 to 1969 he served as a trustee of the Tate Gallery and in 1977 he was elected a member of the Royal Academy.

He taught sculpture at Berlin's Hochschule der Kunste (1979-1980) and at the Royal College of Art (1980-1990). From 1990 to 1999 he was professor emeritus at the Royal Academy Schools. In 2000, he was elected president of London's Royal Academy of Art.

He has presented numerous solo exhibitions and has participated in a great number of group shows. His works are included in public collections in Europe, Australia, the USA and Japan. He was the first British artist after Henry Moore to be honoured with an exhibition at the Forte di Belvedere in Florence.

Jeremy Moon was one of the major painters in Britain during the 1960s and early 1970s, alongside Bridget Riley. He was born in 1934 and died in 1973 at the age of 39 in a motorcycle accident.

He studied at the Central School of Art and taught at St Martin's School of Art and the Chelsea School of Art. He presented a large number of solo exhibitions at the Annely Juda Gallery, while in 1976 London's Serpentine Gallery held a retrospective exhibition of his work. Works of his are included in the Tate Gallery and the British Council, London, the Calouste Gulbenkian Foundation, Lisbon, and many others.

Eduardo Paolozzi was born in Leith, Scotland, in 1927. In 1943 he began his studies at Edinburgh's College of Art and from 1944 to 1947 studied at London's Slade School of Art. His first solo exhibition was held at the Mayor Gallery in London in 1947. In the same year he left for Paris, where he stayed for two years. He enrolled in the Parisian École des Beaux-Arts and met artists such as Arp, Brancusi, Giacometti and Léger. From 1955 to 1958 he taught sculpture at St Martin's School of Art in London; in 1968 he taught at the University of California, Berkeley, and in 1977 taught ceramics at the Higher School of Applied Arts in Cologne.

In 1981 he became professor of sculpture at the Academie der Bildenden Künste and later taught at the Royal College of Art and at Edinburgh's School of Art. In 1979 he became a member of the Royal Academy and in 1988 received a knighthood.

Peter Phillips was born in Birmingham. He studied at the Birmingham School of Art (1955-1959) and the Royal College of Art (1959-1962). In 1959 he travelled to France and Italy and in 1964 was awarded a Harkness fellowship, left for the USA and settled in New York where he stayed until 1966.

His first solo exhibition was held at the Kornblee Gallery in New York, while he participated in important group shows that took place in London during the 1960s (*Young Contemporaries* and *New Generation*, 1964). He travelled to Africa, the Far East and the USA again. In 1972, Munich's Westfälischer Kunstverein held the first retrospective exhibition of his work. The artist's first solo exhibitions in London were organised in 1976 at the Waddington Galleries and at the Tate Gallery. A retrospective exhibition of his work travelled between 1982 and 1983 to six important museums throughout Britain.

John Plumb was born in Bedfordshire. He studied at the Luton School of Art, the Byam Shaw School of Drawing and Painting and the Central School of Art and Design, in London. He participated in the *Situation* exhibition, organised in 1960 by established art critic Lawrence Alloway (Royal Society of British Artists). He lived and worked in London for a period of forty years and then moved to Devon in 1993, where he has been living ever since. Plumb's intense academic activity includes lectures and courses offered at various universities and other academic establishments (Maidstone College of Art, London Central School of Art and Design and the Slade School).

Bridget Riley was born in London in 1931. From 1949 to 1955 she studied at Goldsmiths' College and from 1952 to 1955 at the Royal College of Art.

She began by painting representational works in a semi-impressionist style, but later turned to pointillism, mainly creating landscapes that alluded to neo-impressionism. She visited the 1958 exhibition of Jackson Pollock's work at the Whitechapel Art Gallery in London, which left a lasting impression on her and had a profound influence on her work. From 1960 on she began exploring the impact of visual phenomena. She eventually became established as Britain's premier Op Art representative. Her first solo exhibition was held at Gallery One in London, in 1962. At the Venice Biennale of 1968 she received the international award for painting. She has presented numerous solo exhibitions and has participated in a great number of group shows.

Following a major retrospective exhibition of her work in early 1970, she began to travel. In 1983 she created a mural for Liverpool's Royal Hospital, consisting of bands of blue, pink, white and yellow, and participated in the production of the *Colour Moves* dance performance, which was presented at the Festival of Edinburgh.

In 1993 and 1994 she received an honorary PhD from the University of Oxford and the University of Cambridge respectively.

Peter Sedgley was born in London in 1930. He studied architecture at Brixton's Technical College (1944-1946) and worked in various architectural offices from 1947 to 1959. Between 1957 and 1958 he founded the Building Technicians Cooperative and produced innovative designs for buildings and furniture.

In 1959 he began learning to paint and in 1963 he embarked on his career as a painter. In 1964 he participated in an exhibition held at the Museum of Modern Art in New York, entitled *Responsive Eye*. His first two solo exhibitions were held simultaneously in London and New York, at the McRoberts and Tunnard Gallery and the Howard Wise Gallery respectively.

Colin Self was born in Norwich, in 1941, and studied at London's Slade School (1961-1963). During his studies at the Slade he met and exchanged ideas with David Hockney and Peter Blake, who both appreciated and encouraged his interest in drawing and collage. In developing his ground-breaking ideas he experimented with different media such as drawing and sculpture, but also photography and collage.

In 1986, the ICA (Institute of Contemporary Art) presented a solo exhibition of his work entitled *Colin Self's Colin Selfs*, thus making a satirical comment on a popular exhibition of the time entitled *Picasso's Picassos*. In 1995, the Tate Gallery presented a large number of works by the artist, all of which belonged to its collection.

Richard Smith was born in Letchworth, Hertfordshire. He studied at the Luton School of Art (1948-1950), at St Alban's School of Art (1952-1954) and the Royal College of Art (1954-1957). In 1954 he presented his work in the *Six Young Contemporaries* group exhibition held at London's Gimpel Fils Gallery. Having been awarded a Harkness Fellowship he left for New York, where he stayed from 1959 to 1961. During that time he presented his first solo exhibition at the Green Gallery. He returned to New York and stayed there again from 1963 to 1965. In 1962 he presented his work at his private studio on Bath Street and at the ICA (Institute of Contemporary Art).

He participated in the 1961, 1962 and 1966 *Situation* exhibitions. The Whitechapel Art Gallery presented a major exhibition of his work created between 1958 and 1966. In 1976 he once again returned to New York, where he would settle permanently.

Smith has created important works of impressive dimensions for public spaces, such as the Concord Lounge at New York's JFK Airport, as well as the restaurants of the famous Conran chain in London and Paris.

Ian Stephenson was born in Durham and studied at King's College and the University of Durham, under the supervision of Lawrence Gowing, Victor Pasmore and Richard Hamilton (1951-1956). Together with Pasmore he created the 'Developing Process' educational programme, which aimed at promoting a new stream of creativity in art.

His first solo exhibition was held in 1958 at the New Vision Centre. Many of his works were featured in Michelangelo Antonioni's 1960s hit movie *Blow Up*. The first retrospective of his work was organised in 1970 in Newcastle, while in 1977 London's Hayward Gallery presented a major retrospective exhibition of his work entitled *Paintings 1955-1966 and 1966-1977*.

Joe Tilson was born in London in 1928. He was trained as a cabinet-maker at a young age and then served in the British Royal Air Force. He studied at St Martin's School of Art (1949-1952) and the Royal College of Art (1952-1955) alongside Peter Blake and Richard Smith. In 1965 he travelled to the USA where he became acquainted with new media and printing methods. As a result his practice would later rest extensively on the use and development of screen printing.

He participated in the *Young Contemporaries* exhibition held at London's RBA Galleries, as well as in the 1961 Paris Biennial. His first solo exhibition was held in 1962 at the Marlborough New London Gallery.

Isaac Witkin was born in Johannesburg, South Africa, where he would later attend a school of sculpture. He continued his studies at London's St Martin's School of Art between 1957 and 1960, where he was a student of Anthony Caro. He also worked for a time as assistant to Henry Moore (1961-1964). From 1963 to 1965 he taught sculpture at St Martin's School of Art.

In 1965 he participated in the group exhibition entitled *New Generation* held at London's Whitechapel Art Gallery as well as in the Paris Biennial. His work has been presented extensively in major exhibitions both in Europe and the USA. He has presented solo exhibitions at the Rowan Gallery and the Waddington Gallery in London, at the Hamilton Gallery of Contemporary Art and the Marlborough Gallery in New York, at the Locks Gallery in Philadelphia, as well as at the Walker Hill Art Centre, in Seoul, Korea.

BIBLIOGRAPHY

I. GENERAL SURVEYS

AMAYA MARIO, RESTANY PIERRE, GASSIOT-TALABOT GÉRALD ET AL., *Art Since Mid-Century: The New Internationalism*, Vol. 2, *Figurative Art*. Greenwich, Conn.: Graphic Society, New York 1971.

BARRY JUDITH, LAWSON THOMAS, WALLIS BRIAN ET AL., *Modern Dreams: The Rise and Fall and Rise of Pop*, New York: The Institute for Contemporary Art, The Clocktower Gallery; The MIT Press, Cambridge, Mass., and London 1988.

COMPTON MICHAEL, *Pop Art*, The Hamlyn Publishing Group Limited, London, New York, Sydney and Toronto 1970.

CROW THOMAS, *The Rise of the Sixties: American and European Art in the Era of Dissent*, Harry N. Abrams, New York 1996.

FINCH CHRISTOPHER, *Image as Language - Aspects of British Art 1950-1968*, Harmondsworth 1969.

FRITH SIMON AND HOWARD HORNE, *Art into Pop*, Methuen and Co., London and New York 1987.

FOLLIN FRANCES, *Embodied Visions: Bridget Riley, Op Art and the Sixties*, Thames & Hudson, London 2004.

GASSIOT-TALABOT GÉRALD, *La Figuration narrative dans l'art contemporain*, Galerie Europe and Gallery Creuze, Paris 1965.

HUXLEY PAUL (editor), *Exhibition Road: Painters at the Royal College of Art*, Oxford 1988.

LANE HILARY, SINFIELD ALAN, *Ready Steady Go: Paintings from the Arts Council Collection*, The South Bank Centre, London 1991.

LIVINGSTONE MARCO, *Pop Art: A Continuing History*, London, New York, Milan, Paris 1990; revised edition London, New York, Paris 2000.

LUCIE-SMITH EDWARD, *Movements in Art Since 1945: Issues and Concepts*, Thames and Hudson, London 1995.

MASSEY ANNE, *The Independent Group: Modernism and Mass Culture in Britain, 1945-59*, Manchester University Press, 1995.

MELLOR DAVID, *The Sixties Art Scene in London*, Phaidon Press Limited, London, in association with the Barbican Art Gallery, London 1993.

MELLOR DAVID, GERVEREAU LAURENT, *The Sixties. Britain and France, 1962-73. The Utopian Years*, Paris, 1996; London 1997.

WALKER A. JOHN, *Cultural Offensive: America's Impact on British Art Since 1945*, Sterling, London 1998.

II. EXHIBITION CATALOGUES

ALTHEWS F. PETER, *Information: Joe Tilson, Peter Phillips, Allen Jones, Eduardo Paolozzi, Ronald B. Kitaj, Richard Hamilton*, Badischer Kunstverein, Karlsruhe 1969.

CALOUSTE GULBENKIAN FOUNDATION, *Treasure Island*, Centro de Arte Moderna José de Azeredo Perdigão, Lisbon 1997.

COMPTON SUSAN (editor), *British Art in the 20th Century: The Modern Movement*, Royal Academy of Arts, London 1987.

FRIEDMAN MARTIN, BOWNESS ALAN AND REICHARDT JASIA, *London: The New Scene*, Walker Art Center with the Calouste Gulbenkian Foundation, Minneapolis 1965.

GILMOUR PAT, *Hockney to Hodgkin: British Master Prints 1960-1980*, New Orleans Museum of Art, New Orleans 1997.

GOLDMAN JUDITH, *The Pop Image: Prints and Multiples*, Marlborough Graphics, New York 1994.

LIVINGSTONE MARCO (editor), *Pop Art*, The Royal Academy of Arts, London 1991.

The Pop '60s: Transatlantic Crossing, Centro Cultural de Belém, Lisbon 1997.

ROBERTSON BRYAN, THOMPSON DAVID, *The New Generation: 1964*, Whitechapel Art Gallery, London 1964.

SOMERVILLE LILIAN, *5 Young Artists: British Pavilion*, XXXIII Venice Biennale, British Council 1966.

STEPHENS CHRIS, STOUT KATHARINE, *Art & the 60's This Was Tomorrow*, Tate Publishing, London 2004.

VARNEDOE KIRK, ADAM GOPNIK, *High and Low: Modern Art and Popular Culture*, The Museum of Modern Art, New York 1991.

III. SELECTED MONOGRAPHS AND SELECTED SOLO EXHIBITION CATALOGUES

Gillian Ayres: Paintings, Museum of Modern Art, Oxford 1981.

Gillian Ayres, Arts Council, London 1983.

Derek Boshier: Selected Drawings 1960-1982, texts by Marco Livingstone and Derek Boshier, Bluecoat Gallery, Liverpool 1983.

Derek Boshier, introduction by Marco Livingstone, Galerie du Centre, Paris 1993.

Peter Blake, texts by Michael Compton, Nicholas Usherwood and Robert Melville, Tate Gallery, London 1983.

RUDD NATALIE, *Peter Blake*, London 2003.

Anthony Caro, Museum of Modern Art, New York 1975.

Anthony Caro. Sculpture 1969-1984, Arts Council, London 1984.

Patrick Caulfield: Paintings 1963-1981, text by Marco Livingstone, Walker Art Gallery, Liverpool, 1981, Tate Gallery, London 1982.

Patrick Caulfield: Paintings 1963-1992, text by Marco Livingstone, Serpentine Gallery, London 1992-1993.

"Barrie Cook in Conversation with Terry Measham", in *Studio International*, December 1970.

CRICHTON FENELLA, "Barrie Cook at the Whitechapel", in *Art International*, 15 May 1975.

Richard Hamilton, Collected Works: 1953-1982, London 1982.

Richard Hamilton Prints 1939-83, Stuttgart, London 1984.

Richard Hamilton, texts by Richard Morphet and others, Tate Gallery, London 1992.

David Hockney, Musée des Arts Décoratifs, Palais du Louvre, Paris 1974.

HOCKNEY DAVID, *David Hockney*, London 1976.

David Hockney: A Retrospective, Los Angeles County Museum of Art, Los Angeles 1988.

Howard Hodgkin: Forty-Five Paintings, 1949-1975, text by Richard Morphet, Arts Council of Great Britain 1976.

GRAHAM-DIXON A., *Howard Hodgkin*, New York 1994.

John Hoyland: Paintings 1960-1967, Whitechapel Art Gallery, London 1967.

John Hoyland: Paintings 1967-1979, Serpentine Gallery, London 1979.

JENCKS CHARLES, ARWAS VICTOR, ROBERTSON BRYAN, *Allen Jones*, London 1993.

LIVINGSTONE MARCO, *Allen Jones Prints*, Munich and New York 1995.

Phillip King, edited by D. Thompson Otterlo, Kröller-Müller 1974.

Phillip King, edited by R. Kudielka, Hayward Gallery, London, 1981.

KONNERTZ WINFRIED, *Eduardo Paolozzi*, Cologne 1984.

Eduardo Paolozzi: 1924-1994 - A Birthday Celebration, Sculpture Park, Yorkshire 1994.

PEARSON FIONA, *Paolozzi*, Edinburgh 1999.

Peter Phillips retroVISION: Paintings 1960-1982, text by Marco Livingstone, Walker Art Gallery, Liverpool 1982.

Bridget Riley: Paintings and Drawings, 1961-1973, Arts Council of Great Britain 1973

Bridget Riley: Works 1959-1978, British Council Collection 1978.

Bridget Riley, Selected Work 1963-1984, Goldsmiths' College Gallery, London 1985.

Colin Self's Colin Selfs, text by the artist, Institute of Contemporary Arts, London 1986.

Richard Smith: Seven Exhibitions 1961-1975, text by Barbara Rose, Tate Gallery, London 1975.

Richard Smith: The Green Gallery Years 1960-1963, essay by Marco Livingstone and conversation with Richard Smith, Richard L. Feigen & Co., New York 1992.

COMPTON MICHAEL, LIVINGSTONE MARCO, *Tilson*, Milan 1993.

Tilson: Pop to Present, essay by Mel Gooding, Royal Academy of Arts, London 2002.

Exhibition organisation and catalogue publishing
Basil & Elise Goulandris Foundation

Exhibition curators
Ana Vasconcelos e Melo
Richard Riley
Kyriakos Koutsomallis

Catalogue editorial supervision and co-ordination
Kyriakos Koutsomallis
Margarita Kataga
Elena Paleokosta

Entries and Biographical Notes
Margarita Kataga
(pp. 46, 50, 57, 58, 59, 60, 70, 72, 73, 75, 82, 84, 88, 90, 92, 94, 96)
Elena Paleokosta
(pp. 38, 40, 43, 47, 52, 54, 56, 64, 68, 76, 78, 79, 85, 87)

Translations from Greek
Klio Panourgias (Ros Schwartz Translations, London)
Maria Skamaga

Secreteriat
Alexandra Papakostopoulou

Editing and proofreading for the Basil & Elise Goulandris Foundation
Lito Tsekoura

Editing and proofreading for the publisher
Harriet Graham

Artistic conception and catalogue printing
Umberto Allemandi & C.

Editorial coordination for the publisher
Elena Aleci

Maquette
Carlo Nepote

Exhibition graphics and labelling
Magdalena Papanicolopoulou

Communications
Irini Antoniou

Insurance of works
Progress Fine Art

Transport of works
Orphée Beinoglou
MOMART
FeirExpo PORTUGAL

SOCIETÀ EDITRICE UMBERTO ALLEMANDI & C.

TURIN ~ LONDON ~ VENICE ~ NEW YORK